LOST
MILWAUKEE

LOST
MILWAUKEE

CARL SWANSON

Published by The History Press
Charleston, SC
www.historypress.com

Copyright © 2018 by Carl Swanson
All rights reserved

The cover photograph of Chicago & North Western Railway's Lake Front Depot was captured around 1890. The elegant little station had unusual touches, including a bridal suite on its second floor with a view of the lake. The last train called on the depot in 1966. It was demolished two years later, becoming another example of lost Milwaukee. *Courtesy of the Library of Congress/Detroit Publishing Company.*

First published 2018

Manufactured in the United States

ISBN 9781467138635

Library of Congress Control Number: 2017963239

Notice: The information in this book is true and complete to the best of our knowledge. It is offered without guarantee on the part of the author or The History Press. The author and The History Press disclaim all liability in connection with the use of this book.

All rights reserved. No part of this book may be reproduced or transmitted in any form whatsoever without prior written permission from the publisher except in the case of brief quotations embodied in critical articles and reviews.

To Judy

CONTENTS

Acknowledgements 9
Introduction 11

I. SETTLEMENT AND GROWTH
1. From Trading Post to City 14
2. The Great Trouser Disaster 18
3. The Lost Canal 21
4. When Lincoln Came to Town 25
5. Soldiers' Home 29

II. ENTERTAINMENT
6. The Lost Park 34
7. Shorewood's Amusement Park 38
8. Drinking Pabst in Whitefish Bay 43
9. Just a Neighborhood Theater 47
10. He Taught Milwaukee to Dance 50

III. MACHINE SHOP TO THE WORLD
11. Lawson's Airliner 56
12. The Ice War 64
13. Evinrude Test Facility 69
14. The Little Engine that Couldn't 74
15. The Sweetest Story 78

Contents

16. Grenades and Underwear	82
17. Eline's Chocolate	85
18. Deaf Workers Aided War Effort	88
19. Hungover? Quaff-Aid to the Rescue!	91
20. The Day Schlitz Closed	94
21. Park Has an Industrial Past	100

IV. Life and Death in Old Milwaukee

22. Milwaukee's Favorite Lake Trip	108
23. Shipwreck in Downtown Milwaukee	114
24. "Marriages Solemnized Here"	118
25. The Lost Business District	121
26. Tragedy at the Orphanage	125
27. The Hatpin Ordinance	129
28. The Tuberculosis Park	132

V. Streetcar Days

29. The Depot in Lake Park	136
30. Thrills on the Wells Street Viaduct	139
31. A Sometimes Strange History	143

VI. Steam and Fast Trains

32. A Tale of Two Depots	148
33. Four Hundred Miles in Four Hundred Minutes	152
34. The Beer Line	156
35. An Upriver Mystery	159

VII. Lost River Landmarks

36. A River Made for Recreation	162
37. Milwaukee Cement Company	166
38. Estabrook's Lost Beach	170
39. A Boat Named *Killjoy*	174
40. A Duck Named Gertie	178
41. The Lost Neighborhood	182
42. Amid the Ruins	185

Notes	189
Index	201
About the Author	208

ACKNOWLEDGEMENTS

I t happened like this.
I came across a concrete foundation deep in the woods along the Milwaukee River not far from my home. Wondering what had once been there sent me on a search through the past, one that continues to this day. Along the way, I thought others would be interested in what I'd learned, so I started a blog, MilwaukeeNotebook.com. More posts followed and became the book you are now holding.

That there is a book at all is largely due to John Rodrigue, commissioning editor at The History Press. John not only suggested the project, he provided the book's overarching theme. Production editor Abigail Fleming's careful and sensitive editing of the text is especially appreciated.

In particular, I thank Joseph Kmoch for his early interest in the project and his many helpful suggestions. My wife, Judy, and children, John, Daniel and Rachel, have been remarkably supportive throughout this project. Their presence in my life means more to me than I can express. John tracked down photographs and other information, much of it from the archives of the Milwaukee County Library and Milwaukee County Historical Society. The friendly assistance of the staff of these institutions, especially MCHS archivist Kevin Abing (author of the recent *A Crowded Hour: Milwaukee during the Great War, 1917–1918* from Fonthill Media), is gratefully acknowledged.

Some of the chapters in this book are based on articles I contributed to the website OnMilwaukee.com and are reprinted by permission. I especially thank Bobby Tanzilo, managing editor of OnMilwaukee.com,

Acknowledgements

for his enthusiastic support of my interest in local history. Bobby's Urban Spelunking series on that site and his book *Hidden History of Milwaukee* (The History Press, 2014) are essential reading.

Several individuals proposed topics or supplied information for *Lost Milwaukee*. Author and historian Thomas Fehring told me about the Briggs Loading Company, which is profiled in the "Grenades and Underwear" chapter. Thomas is the author of the superb *The Magnificent Machines of Milwaukee and the Engineers Who Created Them*, published in cooperation with the Milwaukee County Historical Society, as well as *Whitefish Bay* in the Images of America series and *Historic Whitefish Bay: A Celebration of Architecture and Character*, published by Arcadia Publishing/The History Press. Jeffrey Hoffman called my attention to the ruins of Evinrude's Milwaukee River outboard motor test facility. Dan Soiney suggested the chapter on Flambeau Motors, a much more obscure maker of outboard engines. Dan also provided his photograph of the Grand Theater.

Thanks are also due to the readers of MilwaukeeNotebook.com for their encouragement, additional facts and points of clarification for many of the topics covered in these pages. They include Ron Friedel, Lindsay Korst, Michael Gregoric, Thomas Manz, Marc Ponto, Gregory James, Matthew J. Prigge, Kathleen Wikoff and many others.

The Beer Line chapter is adapted from an article I originally wrote for the May 2004 issue of *Riverwest Currents*.

The stories in these pages are my retelling of events originally described in contemporary newspaper accounts, magazine articles, and published histories of the city. I've credited my sources in the text and in the chapter notes. Any errors or omissions are mine. Unless otherwise noted, all photographs in this book were taken by me or are from my collection.

Lastly, I wish to thank those who have followed my blog and shared their love for Milwaukee. This book would not have been possible without their support, comments and suggestions.

INTRODUCTION

The Milwaukee River rises in Fond du Lac and Sheboygan Counties and flows about one hundred miles southward through farms and towns to join with two other rivers, the Menomonee and Kinnickinnic, in what was formerly a broad tamarack swamp surrounded by rolling hills on the shore of Lake Michigan and is now the city of Milwaukee.

The exact meaning of the Indian phrase that gave the river and city their names is debatable. Settler Joshua Hathaway said the name had been derived from the Potawatomi *Main-a-wauk-ee seepe*, which he translated as "gathering place by the river." Hathaway's version is the one generally accepted, although an early Indian language interpreter, Louis Moran, believed the name was from the Ojibwe *Me-ne-waukee*, meaning "beautiful land."[1] In a less romantic vein, author Robert W. Wells quotes a nineteenth-century writer who concluded the name was from the Winnebago *Mee-lee-waug-ee*, "stinking river."[2]

James S. Buck, one of Milwaukee's first European settlers and later the author of a four-volume history of the city, had this memory of his new home, which he first encountered when the area was still part of Michigan Territory.

> *This description will, I think, give a very correct idea of the appearance of Milwaukee in a state of nature. To say that it was simply beautiful does not express it; it was more than beautiful—those bluffs, so round and bold, covered with just sufficient timber to shade them well, and from whose*

Introduction

tops could be seen the lake extending beyond the reach of human vision, while between them ran the river, like a silver thread; not the filthy sewer it is today, but a clear stream, in which the Indian could detect and spear fish at the depth of 12 and even 18 feet, and upon whose surface sparkled the rays of the morning sun, as upon a mirror. No wonder it had received the appellation of the Beautiful Land. I certainly have never seen a more beautiful spot upon the entire lakeshore. Yea, and it is beautiful today, but its beauty today and in 1836 are different. The former was the work of God, the latter of man.[3]

A scant handful of European settlers lived on the riverbanks when Buck arrived in 1836. The city's population had already reached 115,000 when he set down his recollections in the 1880s. Milwaukee's pioneer days were even then an increasingly dim memory, as the fledgling city was entering a time of rapid expansion into one of the nation's leading manufacturing centers. In many ways, its best years were still ahead.

Milwaukee residents would soon be able to board one of the steamboats providing regular service on the river between North Avenue and a popular beer garden on the west bank near Capitol Drive and a large amusement park on the east bank. On the way, they would pass immense multistory icehouses, a factory with one thousand men at work, a riverside bathhouse with throngs of swimmers and a strangely isolated "river colony" of homes. Today, all these have vanished, leaving hardly a trace behind.

In the following pages, we will revisit these places and many other examples, ranging from a high-speed rail line that became a bike path to a courthouse statue representing justice that locals thought resembled a drunken dancing girl.

In gathering the contents for this book, I was especially struck by the changing nature of the river that gave the city its name and played a key role in shaping its industrial development and providing recreational outlets for its citizens. Much has been lost along the Milwaukee River, and much has been lost throughout the city. That's normal and expected. Change is the natural order of things. While Milwaukee is different than it once was, it is still beautiful.

PART I
SETTLEMENT AND GROWTH

1
FROM TRADING POST TO CITY

One recent day in Milwaukee's Juneau Park, a strolling couple paused to look at an imposing statue. Reading the name on the pedestal, one asked, "Who's Solomon Juneau?"

The short answer is he was a fur trader who turned a cabin in the wilderness into a thriving city. He developed the downtown and the East Side. He donated land and materials for the first courthouse. He was Milwaukee's first postmaster, its first village president and, when the city was incorporated, its first mayor.

Juneau made a fortune and lost practically everything. He made many friends and kept them all. The pallbearers in his funeral procession included four chiefs of the Menomonee Nation.

This founder of Milwaukee was French Canadian, born near Montreal, Canada, on August 9, 1793. (He became a U.S. citizen in 1831.) Contemporaries describe him as more than six feet tall, broad-shouldered, with gray eyes and long curly black hair.

He had worked as a voyageur in his youth, finding his way to Mackinac, where he was hired in 1816 by fur trader Jacques Vieau, who conducted an extensive business from his headquarters at Green Bay, including a trading post at Milwaukee. In 1818, Juneau arrived in Milwaukee as Vieau's representative. He also married his employer's eldest daughter, Josette. She was seventeen at the time, and Juneau was ten years older. The couple had a least twelve children.

Settlement and Growth

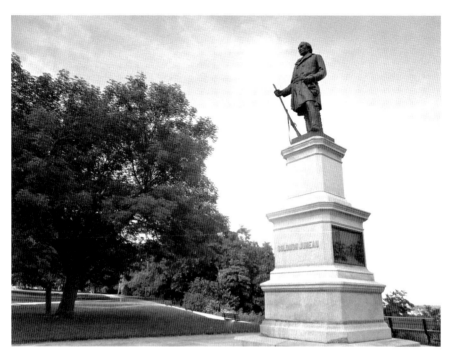

The Juneau Monument, on a bluff overlooking Lake Michigan and the city he founded, was unveiled on July 6, 1887, thirty-one years after Solomon Juneau's death.

The granddaughter of a Menomonee chief, Josette's many acts of kindness made her a much-loved figure among the settlement's Native Americans. For example, she kept a barrel of flour and a barrel of sugar outside her cabin door. Those in need of food but too shy to ask could simply help themselves. Fluent in several Indian dialects, Josette rarely spoke English—French was the primary language in the Juneau household.

The Juneaus were not the first white settlers in Milwaukee, nor was Jacques Vieau, who founded his trading post near the Menomonee River in what is today Mitchell Park. Jean Nicollet passed through around 1639, Father Pierre Marquette paid a brief visit in 1674 and explorer René-Robert Cavelier, Sieur de La Salle, dropped by on his way south to Fort Crevecoeur (Illinois) in 1679. Others, including a wandering blacksmith named Jean Baptist Mirandeau, stayed in the area for a few months or a few years.

A visitor in 1809, nine years before Juneau's arrival, met Vieau, Mirandeau, one or two other French families and several hired men. A

British census in 1817, a year before Juneau's arrival, counted three hundred Native Americans in the area, primarily Menomonees, who claimed the northern part of the future city as their territory, and Potawatomies, who claimed the southern end. There were also Sacs, Foxes, Chippewas, Ottawas and Winnebagos.[4]

Juneau himself probably wasn't a permanent resident at first. He likely spent his summers elsewhere, turning in the furs he purchased over the winter and restocking his trade goods. Unlike the other early Europeans, Juneau recognized Milwaukee's potential. With the backing of a business partner from Green Bay, Morgan Martin, Juneau purchased 130 acres north of today's Wisconsin Avenue and east of the Milwaukee River in 1835 and began selling lots.

In addition to selling land, he frequently gave it away. He contributed land for a lighthouse and a Catholic church and donated both the land and building materials for Milwaukee's first courthouse. Solomon and Josette also donated land and materials to impoverished settlers.

Juneau believed the place where the rivers met Lake Michigan would become a great city—and he wasn't the only one. About the time Juneau was buying land on the East Side, Byron Kilbourn was developing Kilbourn Town on the west side of the Milwaukee River and Colonel George H. Walker was staking a claim south of downtown that would become Walker's Point. Much of the city's early history is marked by the not-so-friendly rivalry between these settlements.

Juneau served a single term as mayor, stepping down in 1847. By then, the wilderness of just a decade before was a bustling community of twelve thousand, and Juneau had lost much of his fortune in a financial downturn. After leaving office, he divided his time between Milwaukee and Theresa, a village he founded forty miles north of Milwaukee and named for his mother.

In 1855, Josette Juneau, who had been ill for some time, died at age fifty-seven. Pioneer settler Uriel B. Smith wrote this memory of Josette:

> *My child, Milwaukee Smith, was born October 10, 1835. She was the first white child born in Milwaukee, and Mrs. Juneau was present at her birth, and attended upon my wife in such a kind and motherly manner as to win the love and esteem of my wife as well as myself.*
>
> *Mrs. Juneau was also an attendant and watcher at the death bed of my wife some two years after....For such services rendered to my wife during her sickness, I offered ample remuneration, which was immediately declined—she saying to me, "Such services were due all, and, that too,*

without consideration." Such incidents can never be forgotten. I trust that Milwaukee today has her equal—I know it has not her superior.[5]

A year after Josette's death, Juneau set off to visit the Menomonee in northern Wisconsin. A tribal gathering was taking place, and Juneau planned to catch up with his old friends and do a little trading. On arriving at Keshena, he became ill with symptoms resembling appendicitis.[6] His condition rapidly worsened, and on November 14, 1856, a Catholic priest administered last rites.

Juneau remarked to a friend, "It is hard to die here. I had hoped to lay my bones in Milwaukee." Then, with a peaceful expression on his face, he said his final words, "I come to join you, my wife."[7]

Grieving tribal members arranged one of the most impressive funerals in the state's history. With a priest leading the way, Juneau's casket was carried by ten pallbearers, including Chief Oshkosh and three other Native American chiefs, while tribal members—about seven hundred—marched silently behind in orderly rows.

He was initially laid to rest in a grave atop a hill behind the Menomonee council house. When Juneau's children arrived to take his body back to Milwaukee, the Menomonees escorted the remains as far as Shawano. On returning, they planted an evergreen tree in Juneau's open grave. His spirit, they said, would forever remain with the tribe.

When Juneau's body reached Milwaukee, a funeral was held at St. John's Cathedral, and he was buried in the Old Cemetery. Following the purchase of the land that became Calvary Cemetery on the west side, Juneau's remains were moved again. In 1946, the Milwaukee Common Council commissioned a monument, which stands near the cemetery entrance.

"Solomon Laurent Juneau was a man of rare personality," wrote granddaughter Isabella Fox in 1916. "While of a jovial temperament, he never for a moment lost his natural dignity; of a kind and benevolent nature, he was the friend and confidant of all."[8]

2
THE GREAT TROUSER DISASTER

Early settler James S. Buck wrote the four-volume *Pioneer History of Milwaukee*, which one writer described as "a fascinating hodgepodge of largely undigested facts, gossip, puffs and salty observations."[9] Buck included events both great and small in the city's formative years. For example, many historians relate the construction of Milwaukee's first courthouse in what is today Cathedral Square, but only Buck gave us "The Courthouse Trouser Disaster."

Solomon Juneau, Milwaukee's founder, and his business partner, Morgan Martin, built the city's first courthouse and adjoining jail annex in 1836. The wooden two-story building cost the men $8,000, a considerable sum in those days. On completion, Juneau and Martin, who jointly owned much of what is today the East Side, donated the building and its plot of land to the county.

The first courthouse was "an attractive two-story structure 40 feet wide by 50 feet deep on the north side of the park near what is now Kilbourn Avenue. Its main entrance faced south toward the park."[10]

It was also deep in the woods in those years and a considerable distance from the little village. At one point in its construction, a worker shingling the roof of the courthouse abruptly dropped his hammer, picked up a rifle and shot a passing deer. A low fence was necessary to prevent cows from grazing on the courthouse lawn. Their mooing was disturbing the process of justice.[11]

The two-story courthouse featured a peaked roof with a cupola on top and a porch across its front. One account said, "It was a white colonial type

of building and had a charming effect for so small a structure. The interior contained one courtroom and four jury rooms."[12]

That courtroom witnessed some of the most dramatic moments in the early settlement. For example, in 1854, three men were tried here for breaking into the city jail and rescuing fugitive slave Joshua Glover. A jury acquitted them.

Thirteen years earlier, Buck had been present at a less significant but equally memorable scene. In 1841, Buck reported, many residents attended a public meeting in the courthouse and sat crowded together on the rows of wooden benches—recently varnished wooden benches, as it turned out.

When the meeting ended, all rose at the same moment, accompanied by a mighty rending of fabric. "There was a great destruction of pants," Buck wrote, "nearly everyone present leaving a part of the seat of 'his'n' as a souvenir. The noise made when they attempted to rise was like the rising from the ground of a thousand pigeons."[13]

That first courthouse was replaced by a much larger and vastly more ornate structure in 1873, designed by a Russian immigrant, Leonard Schmidtner, who seems to have been inspired by St. Isaac's Cathedral in Saint Petersburg. (Schmidtner's real name was Baron von Kowalski, and

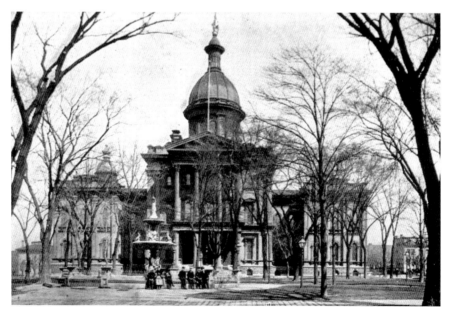

The contract for Milwaukee's second courthouse was awarded in 1868. Like the original courthouse, it stood in what is today Cathedral Square.

he was the son of the royal architect of Russia.) His courthouse was often criticized for its clumsy proportions and its odd mix of styles and materials. Decades after it was constructed, a local architect acidly said, "The building is a typical example of the products of the architects of the period often termed the dark ages in art and architecture."[14]

The courthouse dome was originally adorned with a gilded statue called the *Goddess of Liberty*. A few years after the building's completion, a storm left the goddess tilted precariously on her perch. Local wits began referring to the "courthouse dancing girl" and suggested she had clearly been drinking. After several failed repair attempts, the statue was hauled down and sold for its scrap value.[15]

The second courthouse served Milwaukee until the present courthouse opened ten blocks west in 1931.

There is no trace of the former courthouses in Cathedral Square, although a marker in the two-acre park tells the dramatic story of the freeing of Joshua Glover. It is silent on drunken goddesses and trousers.

3
THE LOST CANAL

As a business venture, the North Avenue dam failed to live up to its potential, but no engineering project did more to define the city's character.

The idea of the dam, portions of which can still be seen, was born in the mid-1830s, when Byron Kilbourn, the developer of the section of the city west of the Milwaukee River, envisioned a canal extending from Milwaukee 180 miles west to the Mississippi. The plan was to excavate connections between existing waterways (the Milwaukee, Menomonee, Rock and Wisconsin Rivers and the chain of lakes in the Madison area).

Kilbourn, nothing if not ambitious, saw riches for the taking. After all, the 363-mile Erie Canal had just been completed across New York State and was a great success. Kilbourn's project appeared easy enough to build and promised to be a near-certain moneymaker, for canals were the only way to cheaply move large amounts of cargo across the country in those pre-railroad days.

He announced his plans and founded the Milwaukee & Rock River Canal Company. Construction was funded through the sale of bonds authorized by territorial government of Wisconsin.

The canal was ill-omened from its start. At its groundbreaking ceremony on July 4, 1839, after the brass band played and suitable speeches had been made, Kilbourn set the blade of a grain scoop shovel—probably selected as symbolizing the grain that would soon move over the canal—on a triangular plot of land at the southeast corner of Third and Cherry Streets. He planted

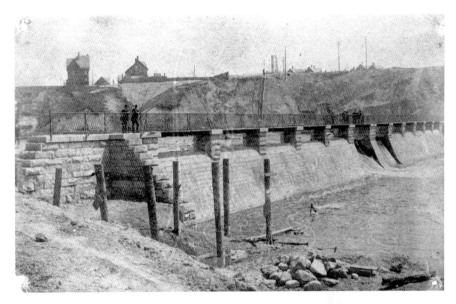

Built for a never-completed canal, the North Avenue dam, shown in the 1890s, opened the upper Milwaukee River to recreation and industry.

his foot on the back of the blade and stepped down hard. The lightweight scoop instantly crumpled.[16]

"The look of mingled disappointment, mortification, rage and disgust which came over the face of Mr. Kilbourn, at this *faux pas*, I shall never forget while life remains," pioneer and historian James Buck wrote. "He threw the treacherous and disabled scoop upon the ground with an exclamation that sounded like profanity."[17]

A replacement shovel was located, and the ceremony finally ended. A fine meal and a great deal of champagne followed, after which, Buck wrote, everyone felt much better.

Kilbourn started digging the first section of his canal along what is today Commerce Street. A dam across the Milwaukee River south of North Avenue, built four years before, in 1835, ensured a steady, controllable flow of water for the canal. At 480 feet long, 85 feet wide and 18 feet tall, the dam was made from logs, earth fill, and gravel.[18]

For a time, canal work went well. The first mile was soon completed from just east of Humboldt Boulevard to Cherry Street (near today's Schlitz Park complex). However, the territorial legislature abruptly had a change of heart about backing the project, and construction sputtered to a halt. The canal company went bankrupt in 1866.

Settlement and Growth

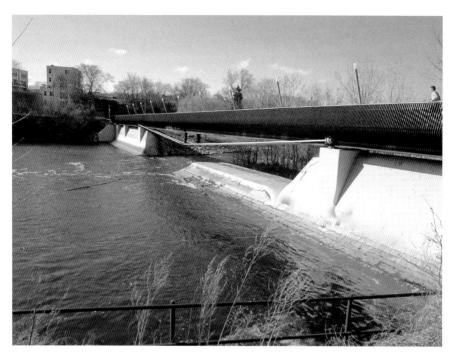

Since the late 1990s, the Milwaukee River has flowed freely through the remnants of the North Avenue dam. Sections of the old dam support a pedestrian bridge.

By then, the city no longer had a dam. It collapsed in a spring flood that same year, 1866, sending a wall of water and debris downstream, damaging or destroying several bridges.[19] The dam was soon replaced and, *Wisconsin Natural Resources* magazine noted, served several purposes:

> *A new dam was built in 1891 to control flooding and regulate water between the upper and lower portions of the river. The 2.5-mile-long 82-acre impoundment created behind the dam was a prime place of leisure and recreation for many Milwaukeeans. Swimming schools, beaches, passenger ferries, boat liveries, rowing schools and commercial icehouses thrived above the dam. Ships and barges continued to use the lower river to meet the transportation needs of the machine shops, breweries, tanneries, paper mills, factories and other industries located along the river.*[20]

Patched and rebuilt several times over the years, the North Avenue dam lasted far longer than the canal. It was partially removed in 1997 to restore

natural water levels along much of the urban river. Its foundations now support a pedestrian bridge.

While it lasted, the dam served as a dividing line between the working world of the lower river and the tree-lined, peaceful upper river.

This sense of the upper river as special and set apart has outlived the dam itself.

4
WHEN LINCOLN CAME TO TOWN

The saddest week in Milwaukee's history, as one account described it, followed the April 14, 1865 assassination of Abraham Lincoln. Wrote William George Bruce, "The city was hushed in grief. Silently and sorrowfully the buildings…were clad in the habiliments of woe."[21]

Many of those Milwaukeeans remembered Lincoln's visit to the city just six years earlier.

Lincoln was already a well-known figure in 1859. His fiery debates with Stephen Douglas had won Lincoln national prominence. His speech the previous year, which concluded, "A house divided against itself cannot stand. I believe this government cannot endure permanently half slave and half free," was widely republished and admired throughout the state. It was only natural the directors of the Wisconsin State Fair invited him to speak.

The fairgrounds were then located between Wisconsin and Highland and from Tenth to Thirteenth Streets. The spot where Lincoln delivered his speech is just north of today's intersection of Twelfth and Wisconsin, then the western edge of town. A small historical marker at Thirteenth and Wells commemorates the occasion.

The night before the speech had been an unusual one. Arriving after midnight, Lincoln went to his hotel, the Newhall House, where he was told of a mix-up. His room had mistakenly been given to another. Lincoln, his friend John Wesley Hoyt recalled in a 1904 address before the Wisconsin Society in Washington, D.C., was untroubled. The future president asked only that a cot be placed next to the hotel's counter, assuring the clerk,

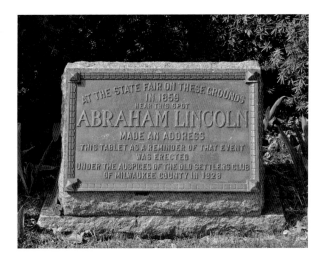

The old country fairgrounds, where Abraham Lincoln spoke in 1859, is commemorated by this marker on the Marquette University campus.

"I have neither insomnia nor indigestion and shall sleep like a top."[22]

When Hoyt arrived in the morning to accompany Lincoln to the fairgrounds, he found the city's distinguished guest shaving behind a folding screen in the lobby. Having indeed slept well, Lincoln was in a cheerful mood and enjoying the absurdity of the situation.

After looking over the prizewinning livestock and the latest agricultural implements with considerable interest (he had been a farm boy, after all), Lincoln, dressed in a black frock coat and his customary stovepipe hat, mounted a wagon to deliver his remarks. His honorarium for the speech was $150, a very good fee in 1859. Mindful of his audience as any good politician must be, Lincoln mostly confined his remarks to agriculture.

"One feature, I believe, of every fair, is a regular address," Lincoln began, "The Agricultural Society of the young, prosperous, and soon to be, great State of Wisconsin, has done me the high honor of selecting me to make that address upon this occasion—an honor for which I make my profound, and grateful acknowledgment."

The speech went on at great length and touched on a variety of agricultural topics. For example, Lincoln envisioned a time steam-powered machines would plow fields.

As Lincoln's speeches go, this one "suffers from tedium," in the succinct description of the website Abraham Lincoln Online. Still, historians say the speech is significant in understanding Lincoln's thoughts on agriculture and the benefits of education for common laborers.

Having given the crowd a solid $150 worth, Lincoln wrapped up his remarks by noting prizes were to about to be awarded:

Settlement and Growth

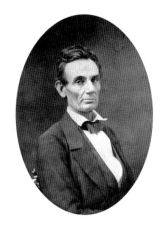

Abraham Lincoln sat for this photograph in Chicago a few weeks after his speaking engagement in Milwaukee. *Courtesy of the Library of Congress.*

It is said an Eastern monarch once charged his wise men to invent him a sentence, to be ever in view, and which should be true and appropriate in all times and situations. They presented him the words: "And this, too, shall pass away." How much it expresses! How chastening in the hour of pride! How consoling in the depths of affliction! "And this, too, shall pass away." And yet let us hope it is not quite true. Let us hope, rather, that by the best cultivation of the physical world, beneath and around us; and the intellectual and moral world within us, we shall secure an individual, social, and political prosperity and happiness, whose course shall be onward and upward, and which, while the earth endures, shall not pass away.[23]

His talk over, Lincoln stepped down, shook hands with dignitaries and was escorted to a nearby tent for lunch. Hoyt, having stayed behind to deliver some remarks of his own, found Lincoln seated in front of a twenty-foot-tall display of flowers and fruit, with a lavish lunch spread before him and "surrounded by a multitude of ladies." Lincoln greeted his friend cheerfully: "Had ever mortal man such backing and such surroundings?"

The two strolled across the fairgrounds after lunch—just a visiting politician from Illinois and a friend with the rest of the day to spend at the fair. They attended a sideshow performance featuring a circus strong man, "nearly as broad as high." Hoyt said Lincoln was amazed by the performance. As the man tossed iron balls and lifted immense weights, a delighted Lincoln repeatedly said, "By George!"

Introduced to the performer after the show, Hoyt said the six-foot, four-inch Lincoln smiled down at the much shorter man and said, "Why, I could lick salt off the top of your hat!"

That night, a crowd of political supporters gathered at the Newhall House, where Lincoln was staying. (The Newhall House, located on the northwest corner of Michigan Street and Broadway, was one of the finest hotels in the West. In 1883, it suffered a devastating fire that claimed sixty-four lives.)

Standing on a box of canned goods in the lobby of the hotel, Lincoln delivered an impassioned attack on slavery. Unfortunately, no written record of his second Milwaukee speech exists.

It was Lincoln's last visit to the city. Six years later, on April 15, 1865, having fought a war to preserve the union and end slavery, Lincoln died. He was fifty-six years old.

5
SOLDIERS' HOME

Soldiers' Home, or to use its formal name, the Northwestern Branch of National Home for Disabled Volunteer Soldiers, is a collection of twenty-five historic buildings on the grounds of what is today the Clement J. Zablocki Veterans Administration Medical Center.

The grounds are expansive, well-maintained and peaceful, but visitors are few and far between. That's a dramatic change from the home's early years, when a day at Soldiers' Home was a popular outing for Milwaukee residents. Outdoor concerts were especially well attended. (The soldiers had a well-regarded brass band.)

According to an 1877 guide book, "To omit a visit to the Soldiers' Home would be to miss one of the most attractive sights Milwaukee affords.… Winding roads, smooth and carefully kept, lead the visitor through delightful groves, and every now and then skirt the bank of a tiny, foliage-fringed lake, whose mirrored surface reflects the beauty surrounding it."[24]

Today, several of the most significant buildings are empty and deteriorating, although the five-story main building, which once housed disabled veterans of the Civil War, is being adapted to new purposes.

The hospital traces its roots back to 1861, the same year the country was plunged into the Civil War. With Wisconsin volunteers signing up for the Union cause, Milwaukee residents began thinking about ways to support the soldiers.

As the war dragged on and casualties mounted, the need to provide care for disabled soldiers became apparent. In April 1864, local women banded

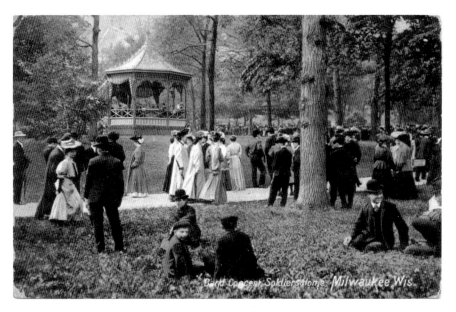

In the late 1800s and into the early 1900s, Soldiers' Home was a popular place for Milwaukee residents to spend a Sunday afternoon.

together and established a temporary home in downtown Milwaukee. By May 1867, Union soldiers had been provided with 150,167 free meals, and more than one thousand received medical treatment. Moreover, the women had raised $110,000, a staggering amount of money in the 1860s, and obtained a state charter for construction of a permanent facility.[25]

Three million men fought in the Civil War, and, as historian Suzanne Julin noted, "Unprecedented casualties, serious wounds caused by modern firearms, and disease and trauma took an enormous toll on these participants. Nearly three hundred thousand Union men who survived the warfare suffered gunshot wounds. By war's end, thirty thousand of them had experienced amputation or loss of use of an injured limb."[26]

In March 1865, the U.S. Congress passed legislation establishing a framework for national centers for care and President Abraham Lincoln delivered his second inaugural address, which included an appeal to the nation to "care for him who shall have borne the battle."

The women turned over the funds they had raised to the federal government, and in this way, through many twists and turns, the local relief effort evolved into a regional center that was part of a national system of care for disabled veterans. The Milwaukee branch opened in 1867—one

of the original three such facilities in the nation. By 1895, Soldiers' Home had 2,421 residents.

Admission was open to honorably discharged disabled veterans with medically certified injuries preventing them from supporting themselves by ordinary means. Life in the center was organized along military lines, with residents assigned to a company of men of roughly similar levels of disability overseen by a captain. Residents lived in large open dormitory-style rooms and were provided an armchair, an iron bedstead with wire springs, a wool mattress, four blankets, a pillowcase and sheets. They were expected to keep these items tidy and—to the extent their disability allowed—assigned a half day of light duty per week, such as assisting with meal preparation or helping around the grounds.

In their spare time, veterans enjoyed a library stocked with 3,000 books, 27 daily newspapers, 130 weekly papers and 37 magazines. Solders could also take classes in bookkeeping, music, telegraphy and printing.[27]

A large theater on the grounds offered frequent and varied performances. Bedtime was 9:00 p.m., and residents rose at 6:00 each morning. Lastly, they had to bathe at least once per week.

It was a spartan life, but it provided food, shelter and medical care for many damaged men. Just as importantly, it gave them a sense of purpose and belonging.

"Old Main" is the signature building in the Soldiers' Home complex. It was built shortly after the end of the Civil War.

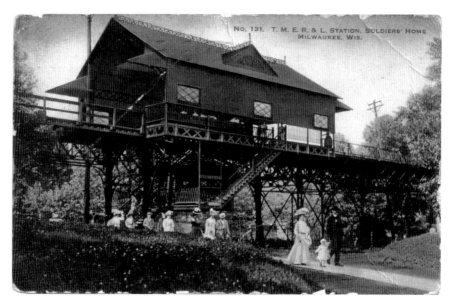

One of the two streetcar stops serving Soldiers' Home. Easy transit access made the grounds a popular destination in early Milwaukee.

The old warriors also had plenty of company. For many years, Sunday afternoon band concerts at Soldiers' Home routinely drew many visitors. The grounds were especially popular on patriotic holidays. The July 5, 1889 *Milwaukee Sentinel* reported a good-natured crowd of more than thirty thousand attended that year's Independence Day festivities, watched over by a temporary police force of seventy old soldiers. At sunset, the grounds were illuminated with thousands of lanterns, and visitors danced until well past midnight.

"The evening scene at the home was grand beyond description," wrote the *Sentinel* reporter. "All the buildings were illuminated, the 6,000 flags, which had fluttered among the branches of the thousands of trees during the day, drooped gracefully as the day of glory died away, and the light of 5,000 Chinese lanterns hung among the trees and along the miles of drives throughout a hundred acres, tinged the vast scene with a peculiar and picturesque grandeur."

As an article in the October 16, 1921 *Milwaukee Journal* noted, "It was a common thing to hear someone conclude a discussion on the infant subject of public parks with the remark, 'Milwaukee did not need public parks while it had Soldiers' Home.'"

PART II
ENTERTAINMENT

6
THE LOST PARK

Pleasant Valley Park, on the Milwaukee River at the foot of East Concordia Avenue, is a peaceful place. The band packed up and left a century ago, about the time steamboats stopped calling at the park's landing stage. A little later, the landing stage, refreshment pavilion, cottages and band shell were torn down and the rubble removed. Officially, this is a Milwaukee County Park, but you wouldn't know it by looking at it. There are no signs, no parking area, no picnic benches or ball fields, nothing at all to suggest it had ever been anything other than a ravine filled with downed trees and garlic mustard.

Yet, as author Tom Tobin noted, this was once one of the city's best-known beer gardens:

> *Blatz Park ("Pleasant Valley" before 1892) swarmed with picnickers in those days. Troops of large families from St. Casimir's Parish, a mile south, regularly followed a makeshift marching band up Humboldt Avenue to the park, each family pulling a coaster wagon containing a picnic lunch. Steam-powered boats, sailing from a dock just above the North Avenue dam, pulled up periodically at the pier and discharged crowds of passengers. The park had a band shell and later a restaurant. There were also cottages, often rented in the summer, by one account, to actors from a theatre downtown.*[28]

The Blatz Park beer garden opened in 1870, one of many in Milwaukee at the time. The city was home to a thriving population of German immigrants,

Entertainment

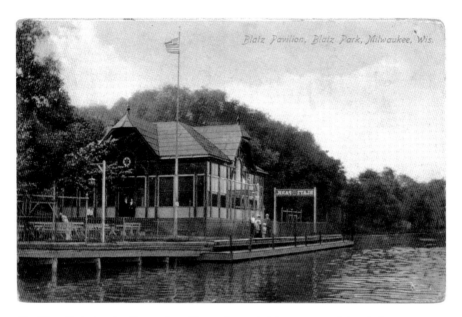

The Blatz Park river landing and pavilion welcomed visitors to one of the city's most popular beer gardens.

and local brewers adopted the old-country idea of the beer garden and elevated it beyond anything ever seen in Germany.

Getting to Blatz Park was half the fun. The river above the dam was served by excursion steamboats operated by several companies located near the North Avenue dam. Under the east end of the North Avenue Bridge, for example, Phillip O'Connor, a former ship's carpenter, built wooden rowboats, which he rented by the half day or full day. His business prospered, and the "Captain," as he was nicknamed, soon built a fleet of steamboats.

A rival operation at the west end of the bridge owned a steamboat called the *Mermaid*, which departed hourly for upriver excursions. The Whittaker family managed a popular swimming school near the North Avenue dam and also ran a steamboat service on the upper river.

At O'Connor's boat livery one could rent a rowboat for twenty-five cents for a half day. For fifteen cents, the less energetic could take a seat on one of O'Connor's three shallow-draft steam launches, which operated between the bridge and the beer garden. The steamers—the *Niswassa*, the *L. O'Connor* and the *Gen. Sheridan*—could carry up to seventy-five passengers, and a round trip (including stops at Blatz Park and the Wonderland amusement park in Shorewood) took forty minutes.

He even built a barge to pull up the river and serve as a floating dance floor and bandstand. On occasion, O'Connor's boats pulled flotillas of canoes tied together. Electric boats powered by storage batteries later augmented the steam launches.

Steamboats played a major role in making the upper river accessible, and the beauty of the winding river with its steep, wooded banks—not to mention the beer, sausages and music—kept the customers coming back.

The gardens faded around World War I as tastes in entertainment changed. Prohibition, followed by the rise of the automobile, put the final nails in the coffin. But in its day, Blatz Park was not to be missed. A guidebook published in 1904 recommended it as part of a suggested one-day itinerary for sightseers to Milwaukee:

> *Should time permit, cross the loveliest country roads to Pleasant Valley or Blatz Park across the River and take a supper there* al fresco; *and if you don't vote that they can cook a game supper there to a turn, and understand all the etc's, and that Milwaukee is a jolly place to pass one day in, it must be the fault of your liver.*[29]

The Blatz estate continued to own the property until the 1920s. In announcing the sale of the land to the city, a June 8, 1928 *Milwaukee Journal*

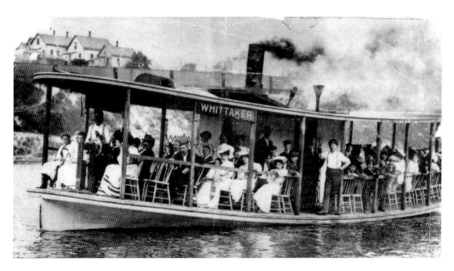

The *Whittaker* is the namesake of George J. Whittaker, who operated a boat rental business adjacent to the family's swimming school at the east end of the North Avenue bridge.

Entertainment

This barge was towed by a steamboat when passenger counts required. On occasion dances were held on it as it floated along.

article noted the beer garden was even then a memory. A swimming school had occupied the park's 790-foot river footage prior to the sale.

"Few of the younger generation in the city realize that there is a spot in the heart of the city that has such beauty," real estate broker Anthony Grueninger told the *Journal*. "However, all old-time Milwaukeeans will remember the days when Pleasant Valley was the recreation place for thousands of people.…While father sat in the famous old pavilion as he quaffed a stein of foaming brew and listened to one of the many singing societies which usually gathered there, mother and the children sat or played about under the beautiful trees of the park."

The sale of the land was intended to facilitate construction of a planned riverfront drive. The roadway was never built, and Pleasant Valley Park eventually became part of Milwaukee County's chain of riverfront parks and slowly reverted to nature.

One writer remembered the old beer gardens of Milwaukee in these words: "All that remains is a hazy recollection of green and white cleanliness, of content and a sense of time standing still on a Sunday afternoon."[30]

Pleasant Valley Park continues to slumber. Its time in the spotlight is over.

7
SHOREWOOD'S AMUSEMENT PARK

Hubbard Park on the Milwaukee River in Shorewood is a quiet place with a surprising history. It was once a farm that became a summer resort. That sleepy resort (its activities revolved around fishing, strolling the shady paths and drinking spring water thought to have health-giving properties) evolved into a sprawling, boisterous amusement park with thrill rides, motorcycle daredevils and dancing girls.

Today's sedate and prosperous community of Shorewood seems an unlikely place for a raucous amusement park, but in a very real sense it represents the village's roots.

The busy park generated not-inconsiderable revenue for Milwaukee. Nearby residents who put up with its noise, crowds and rubbish were irritated this revenue was not earmarked for local improvements. Consequently, voters in 1900, sixty-eight of them, approved a proposal to break away from Milwaukee and establish the independent village of East Milwaukee, renamed Shorewood in 1917.[31]

The good times continued for several more years. When the amusement park closed for good in 1917, its property was divided into parcels and sold to developers.

Only Hubbard Park—a narrow strip of riverfront 1,400 feet long—remains. The land occupied by the park has been used for recreational purposes since 1872, when Frederick Lueddemann, the owner of a thirty-three-acre farm atop the high bluffs overlooking the Milwaukee River south of today's Capitol Drive, opened Lueddemann's-on-the-River as a picnic ground. A

Entertainment

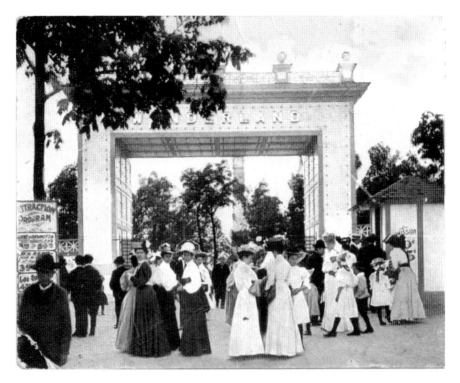

The Oakland Avenue entrance to Wonderland amusement park included a playground, ticket booths, and an elaborate entrance arch.

year later, the Northwestern Union Railway building north from downtown cut through the property, filling a ravine in the process. To maintain access to the river, the railroad built a pair of cut-stone tunnels, one to accommodate a creek and the other a road. The creek is gone, but the twin tunnels are a familiar feature of today's Hubbard Park.

The same year Lueddemann opened his picnic grounds, a Milwaukee inventor named Otto Zwietusch was awarded the first of what would eventually be more than fifty patents, mostly having to do with the process of adding carbonation to beverages and machinery for bottling soda and beer. He also owned a company that was one of the nation's largest producers of bottled water.[32]

According to an article in the June 25, 1981 *Milwaukee Journal*, Zwietusch purchased Lueddemann's-on-the-River in 1876 for $9,000 and, taking a cue from the natural spring located in a ravine on the north edge of the property, changed its name to Mineral Spring Park. Zwietusch named the

water source Apollo Spring and proceeded to bottle the water and sell it throughout the Upper Midwest.

The thirty-five-acre Mineral Spring Park included a half mile of river frontage with swimming and boating. Zwietusch also built a two-story hotel complete with dancing pavilion, parlors, a billiard room and a restaurant on the site of the Luddemann home. He also created scenic walkways with numerous benches and tables and planted nearly five hundred trees. Many of the trees in today's Hubbard Park were likely planted by Zwietusch.

Sales of the bottled mineral water promoted the resort, the resort promoted the sale of the water and the Oakland Avenue streetcar made it easy for people to reach the resort in that pre-automotive age.

Around 1900, Zwietusch sold the property and focused his energies on making and selling bottling equipment. The new owners renamed the property Coney Island, signaling its transition from resort to amusement park, which was built between the railroad right-of-way and Oakland Avenue. Patrons arrived by streetcar, railroad or steam-powered launches operating between North Avenue and the park, with a stop along the way at the Blatz Park beer garden across the river.

Coney Island closed after just three seasons. In 1905, the park reopened under a new name, Wonderland, and added exciting rides, including a

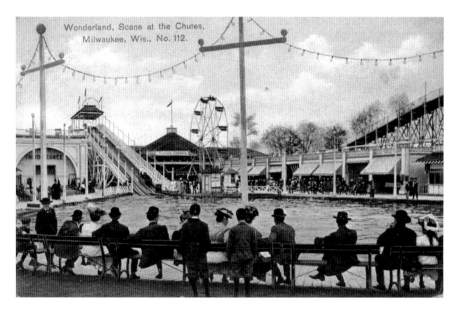

The Chutes was a popular ride. Riders took seats on a flat-bottom boat, which then sped down the ramp and across the surface of the pond.

Ferris wheel and an illuminated Electrical Tower covered with hundreds of lightbulbs, from which daredevils occasionally jumped, landing on a trampoline below.

After paying admission (ten cents for an adult ticket, children five cents) at the park's Oakland Avenue and Menlo Boulevard gate, visitors were entertained by a host of rides, including a giant water slide and a roller coaster. The attractions drew thousands of guests each year.

In 1909, the business changed its name to Ravenna Park, but operations continued much as before. During the season, local newspapers routinely printed highlights of events at the park, such as this example from the July 22, 1911 *Milwaukee Journal*:

> *The largest attractions that can be secured for Ravenna Park are being staged for free features. The big resort stands well to become a popular place for large picnics....Arnoldo's trained leopards, of which there are six that perform in a large cage at one time, is the big free attraction offered this and next week. Arnoldo entering the cage with six leopards is quite a feat, as he has nothing but a whip to defend himself, and the snarling and growling that is heard during the performance would lead one to believe that he might be attacked at any time.*

Three years later, in its June 28, 1914 issue, the same newspaper promised,

> *The management of Ravenna Park has spared no expense this year to please the public. Many new and novel attractions have been secured, including the new vaudeville show composed of a bevy of pretty girls, who dance and sing with grace; the oriental girls, the pit show, stereopticon lecture explaining and showing the recent Titanic and Empress of Ireland disasters. Langheinrich's band furnishes the music.*

In 1917, the Village of Shorewood refused to renew Ravenna's $1,500 annual operating license, and the park closed. Its thirty-three acres were split into three sections. The northern section was subdivided into residential parcels served by extensions of Morris Boulevard, East Newton Avenue and East Menlo Avenue. The streetcar company purchased the southern parcel of land, roughly present-day River Park, and built a transformer building, car barn and offices.

The small remainder of the land, six acres of river bluff squeezed between the railroad right-of-way and the Milwaukee River, was initially

Covered with thousands of lightbulbs, the Electrical Tower was spectacular at night. One park attraction involved a daredevil plummeting from the top.

subdivided and offered as residential lots but eventually sold as a single parcel to form today's Hubbard Park. The deep ravine that once drained through the culvert was filled to extend Morris Boulevard through to the river.

More than one hundred years after Frederick Lueddemann built his picnic ground on this site, a summer beer garden in Hubbard Park opened, bringing the story full circle.

8
DRINKING PABST IN WHITEFISH BAY

In 1889, Captain Frederick Pabst opened a magnificent beer garden, restaurant, hotel and amusement park on 200 wooded acres atop a bluff in Whitefish Bay. With 1,000 feet of lake frontage and about 1,100 feet on Lake Drive, the new Pabst Whitefish Bay Resort occupied one of the finest properties north of Lake Park. It was also then far out in the country, distant from the heat, smoke and noise of the city but still close enough to reach by steam train, horse and carriage, bicycle or one of several boats making regular trips between downtown Milwaukee and the resort.

A 1904 guide for visitors to Milwaukee describes the resort:

> *Resting on the bluff, its site admirably chosen at the very center of a deep, perfectly semi-circular, sweeping bay, upon the grassy bank over a hundred feet above the surface of the water, and shaded by a grove of arching trees, is the pavilion building. It is accessible primarily by the broad and perfect highway already described, by electric cars, the railroad, and by steamer. During the summer season, daily concerts are given by a celebrated band, and rarely do strangers come to Milwaukee who do not spend at least an afternoon or evening at this famous place.*[33]

Fred G. Isenring managed the resort during its first five years under a lease arrangement.[34] The large wooden resort building included two seventy-foot-long wings with a large ballroom and second-floor dining area. Isenring and his successor Henry Konopka made sure a fine dance band was

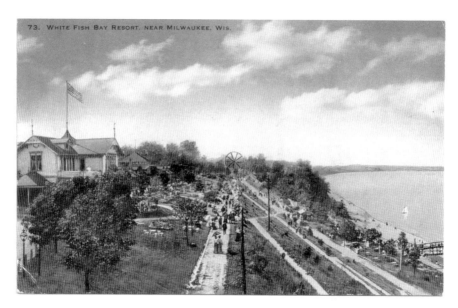

A long switchback sidewalk connected the resort's pier on Lake Michigan with the park grounds atop the high bluff. If nothing else, the climb was good for working up a thirst.

always on hand, and the resort's planked whitefish dinners (the fish being caught in the nearby bay) gave the resort a nationally famous signature dish. Surprisingly for a beer garden, there were days the company's famous lager was not available. The resort was a popular spot for school picnics, and it was an iron-clad rule of Captain Pabst that no beer was to be served while a school group was on the grounds.

The railroad mentioned, the Milwaukee & Whitefish Bay, was a bit of a joke. Early accounts talk of the railway's diminutive steam locomotive, which, with terrific wheezing and puffing, managed to drag a three-car train from Milwaukee to Whitefish Bay, albeit slowly.

The Milwaukee & Whitefish Bay railway was soon replaced by Milwaukee's rapidly expanding streetcar system. The electric cars were quiet, fast and clean. The resort's business surged dramatically. Ten thousand people packed the grounds on a typical Sunday, and streetcar conductors worked twelve- to fourteen-hour days to accommodate the crowds.[35] For this, they earned nineteen cents an hour. The fare was five cents from Whitefish Bay to the Milwaukee city limits. There, riders had to pay an additional five cents if they wished to continue into the city.

Or, as author Gunnar Mickelsen wrote in the February 21, 1932 *Milwaukee Journal*, visitors boarded the trim little steamship *Bloomer Girl*, one of several

Entertainment

The resort could be reached by horse and carriage, bicycle, by steamboat from downtown Milwaukee, and by streetcar.

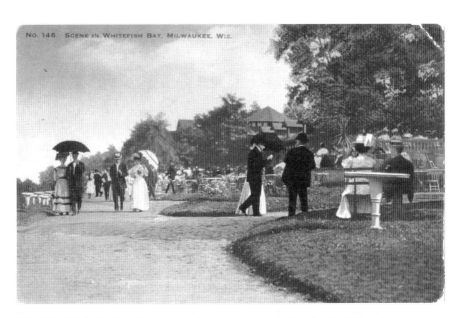

The Pabst Whitefish Bay Resort was a favorite summer destination for Milwaukeeans, as famous for its planked whitefish dinners as it was for ice-cold lager.

serving the resort: "She tied up at the Wisconsin avenue bridge and for a quarter sailed you down the river, gave you a new perspective of your city from the lake and landed you, cool and rested, at the foot of the resort bluff."

Arriving at the long piers at the foot of what is now East Sylvan Avenue, resort visitors climbed a switchback walkway to reach the resort. There was fine food, a large dance floor with a live orchestra and an abundance of Pabst to enjoy while seated at one of the many tables overlooking the lake. There was one more attraction—a Ferris wheel.

The Ferris wheel was invented by George W. Ferris and created a sensation when it was introduced at the World's Columbian Exposition in Chicago in 1893. Later that year, the Pabst resort installed its much smaller version of the famous ride.

Summer after summer, the visitors arrived. Seated at small tables, they enjoyed a lovely view of the curving bay and Lake Michigan while music floated through the trees and children shouted and laughed on the amusement rides.

Time passed and a new generation appeared, one uninterested in the charms of an evening under twinkling lanterns, surrounded by music and loved ones with a glass of lager close at hand.

The Whitefish Bay Resort closed after its 1913 season. The *Bloomer Girl* finished her days shuttling between port cites in South America.

There was talk of making the old garden, with its spectacular views of the lake, into a county park. The Pabst Company, however, had other plans. Divided into residential lots, the land was sold piece by piece. The April 20, 1914 *Milwaukee Journal* noted the sale was not well received:

> The popularity of Pabst park, Whitefish Bay, as an outing ground for residents of Milwaukee was illustrated Sunday when hundreds visited the place, although all the buildings have been taken away and it is being plotted for a residence district. The crowd was so great that the streetcar company found it necessary to run extra cars. The purchases by county or city officials of this resort for park purposes was advocated last year by many people.
>
> "This would have been an ideal outing place," said a man who stood on the high shore overlooking the lake. "Not to buy such grounds as these when opportunity offers shows penny wisdom. People will not realize the loss until this bit of lake shore is closed permanently to the public."

9
JUST A NEIGHBORHOOD THEATER

Empty, deteriorating and facing an uncertain future, the Grand Theater, 2917 North Holton Street, reflects the highs and lows of Milwaukee's movie theater history.

The 790-seat Grand was one of the city's earliest movie houses, opening its doors in 1911—just six years after Milwaukee's first purpose-built theater.[36] By 1930, the Grand was one of eighty-nine theaters in town. By the mid-1950s, only a dozen remained, and the Grand was one of them. It continued operating into the 1970s.

For much of its history, the Grand was a humble "nab"—movie jargon for neighborhood—theater. It was the place down the street where you went as a kid with ten cents to spend and an abiding interest in the latest western.

It offered good value for a dime. Besides the feature presentation, moviegoers saw the current installment of an ongoing serial. These short, episodic films had cliffhanger endings to encourage regular attendance.

Andrew and Evelyn Gutenberg built the Grand when movies were silent. While larger theaters had elaborate organs to provide accompaniment for the films, a neighborhood place like the Grand usually made do with a piano. Indeed, the skeleton of an ancient piano is still on the premises, tucked away beside the former screen.

The Gutenbergs owned a house two blocks north of the theater, where they raised their two children. The movie business being mostly an evening and weekend operation, Andrew Gutenberg also operated a machine shop behind the home.

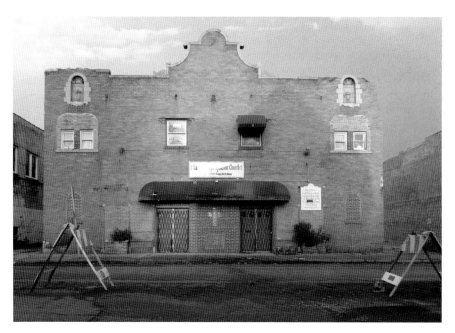

The former Grand Theater on Holton Street is a reminder of the days when every neighborhood had a movie theater.

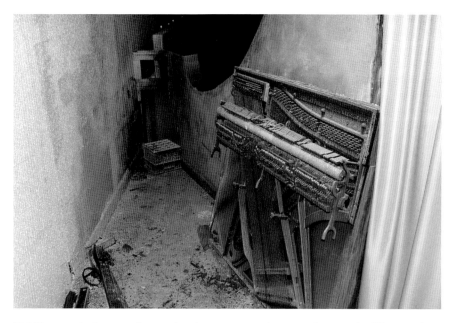

Neighbor movie theaters often used a piano accompaniment to silent movies. The remains of one are tucked behind a wall. *Courtesy of Dan Soiney.*

In 1943, while vacationing in northern Wisconsin, Andrew Gutenberg died following an attack of appendicitis. He was forty-nine. Evelyn took over as owner and manager of the theater.[37]

Evelyn Gutenberg was quoted in a 1958 advertisement for First Wisconsin Bank, "My husband built the Grand, here on Holton Street, the year we were married. Since then, it has always been in the family and pretty much what it is today…a modest, neighborhood movie house and a modestly successful business, just like so many others up and down the street."[38]

The Grand, a late-run discount house, kept going longer than most neighborhood theaters. Around 1970, Matt Millen, a thirty-year-old tax attorney–turned–film enthusiast, took over. He renamed it the Magik Grand Cine. Under Millen's management, the theater showed a mix of foreign films and movie classics. It even hosted experimental live theater. One group, the DMZ Mime Troupe, staged a "Theaterencounter Mind Melt Group Grok" there.[39]

In the mid-1970s, the movie house was purchased by the Church of the Philippians, which owned it until 2007, at which time it was sold to Haven of Hope Ministries. It retains most of its original décor, which can best be described as "American movie theater Mediterranean-ish."

In 2016, the building was offered for sale by the City of Milwaukee for $65,000—that's pretty good for a 7,500-square-foot historic building with a twenty-one-foot-tall ceiling. There were no immediate takers, however, even after the price was reduced to $20,000.[40]

Happy endings are more common in Hollywood than on Holton Street. The odds are against this building's survival.

10

HE TAUGHT MILWAUKEE TO DANCE

If you were out and about in Milwaukee in the early 1900s, you probably knew—or knew of—Andrew Charles Wirth. With his magnificent mustache and his elegant, if eccentric, habit of dressing in white tie, black tailcoat and ballet slippers, "Professor" Wirth was certainly easy to recognize.[41] He owned a statewide chain of dance studios, including several locations in Milwaukee, and he was proprietor of Dreamland Ballroom on Wells Street between Sixth and Seventh.

A biographer described Wirth thus: "Agreeable in manner, an enthusiast in his vocation, popular with those with whom he comes in contact, he is a good example of what one may accomplish with energy and a definite purpose."[42]

At Dreamland, in 1911, Wirth made a remarkable offer. He would teach anyone to dance—free of charge. Wirth's newspaper advertisement explained the offer:

> *Most people cannot understand how we can teach for nothing. It is easily explained. We have an hour every evening that is open, nothing to do during that hour. We want to be busy. We want everyone to become a graceful dancer. We will give that hour to you for nothing. We will give it to you gladly, absolutely free. Come and learn how to dance for nothing in the most beautiful dancing academy in the world. This is just a little work of philanthropy; we want to give you an hour of our time and so do some good; we do not want one hour to be wasted when we can do so much for you in*

Entertainment

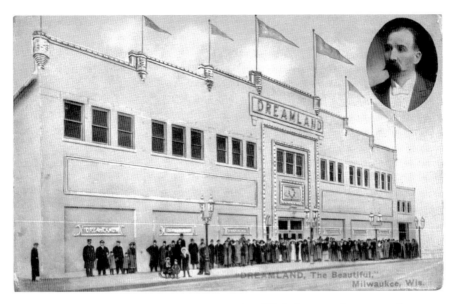

A portrait of dancing instructor "Professor" Andrew Wirth decorates the corner of a postcard view of his Dreamland Ballroom.

> *that time. We are teaching 50 people to dance every week by giving away that hour to our patrons. Why not you?*[243]

It must have been a tempting offer, for Wirth was one of the finest instructors in the state. When this ad appeared in 1911, he had twenty-three years of experience as a dance master. Wirth was proud of Dreamland, where he promised his customers beautiful surroundings and the company of refined patrons. He liked to call Dreamland "The College of Deportment."

Deportment, meaning a graceful bearing and good conduct and manners, is not a commonly used word today, but people certainly felt strongly about it a century ago. Help wanted ads for store clerks insisted on good deportment. Beauty contest entrants were graded on deportment. And here was Professor Wirth's Dreamland, where one entered wishing to dance and emerged with improved decorum and civility.

Who was this nattily dressed man in ballet slippers, teaching the two-step, the waltz and the importance of correct behavior?

Born in Kenosha, Wisconsin, Wirth had an impoverished and difficult childhood. Orphaned at age eleven, he went to work for a farmer in exchange for room, board, and five dollars per month. He used the money to buy his clothing and his schoolbooks. A self-taught musician on cornet

and bull fiddle, he was playing local dances by the time he was twelve. At age sixteen, he went to work in a foundry while studying music in night school.[44]

In 1884, Wirth and wife, Jennie, also a dance instructor, moved to Milwaukee and opened their first dance studio. The couple taught ballet along with the waltz, two-step, redowa, schottische and other nineteenth-century dance favorites. They went on to add seven more locations. Wirth composed music, served as president of the American National Association Masters of Dancing and wrote a well-received instructional book on dancing. In a career that lasted until 1920, Wirth taught thousands of Milwaukeeans to dance.

In 1912, Wirth, with the backing of several business partners, took over the old Hippodrome on Wells Street, renamed it Dreamland and made it into a dance palace.

The Hippodrome was then a local landmark. A multipurpose venue able to seat five thousand, it hosted boxing matches, roller skating, dancing and political rallies. In 1912, Milwaukee Democrats packed the place to hear an address by William Jennings Bryan.

In 1908, the Hippodrome hosted the city's first-ever big money boxing match. On a warm June night, 3,800 fans witnessed one of the greatest fights

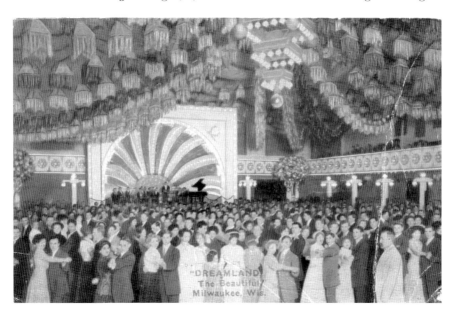

Dreamland, the College of Deportment, was one of many ballrooms operating in Milwaukee in the early 1900s.

in Milwaukee's history. The bout featured reigning middleweight champion Stanley "The Michigan Assassin" Ketchel and challenger Billy Papke.

Ketchel, still regarded as among the greatest middleweights of all time, dispatched earlier opponents with ease, but Papke gave him a scare in Milwaukee. It was a ferocious match. When the bell rang to start the first round, Papke extended a hand to Ketchel for the traditional handshake and was instead punched in the face—and nearly knocked cold. The fight lasted a full ten rounds, with Ketchel victorious in a narrow decision. His winnings totaled $7,640, the equivalent of $185,000 today. Papke consoled himself with second place and $5,093, about $125,000 today.[45]

The lives of both boxers ended violently. In 1910, Ketchel, still holding the championship title, was murdered. He was inspecting a ranch property in Missouri with an eye toward purchasing it and was shot by a ranch hand incensed by romantic advances Ketchel made to the man's common-law wife. The fighter was twenty-three when he died. His opponent in the Milwaukee bout, Papke, died in 1936. Broke, nearly forgotten and living in Newport, California, Papke killed his estranged wife and then himself by firing three bullets into his own body.

The Hippodrome became Dreamland and remained a favorite place to dance through the 1940s. In 1951, the hall was listed for sale, complete with its famous dance floor, three bars and cocktail lounge. It was advertised as suitable for use as a union hall, fraternal organization or veterans' club, but no buyer materialized. The building was torn down.

Today, Dreamland, the College of Deportment, is a parking lot.

PART III
MACHINE SHOP TO THE WORLD

11

LAWSON'S AIRLINER

Back in the early 1900s, when commercial aviation was little more than a handful of barnstorming pilots willing to take a passenger up for a short ride (typically at a dollar a minute), America's first practical multi-engine commercial airliner was built in Milwaukee by Alfred W. Lawson, aviation pioneer, loony visionary and relentless self-promoter.

The Lawson C-2, as it was called, weighed six tons, had a wingspan of eighty feet and seated eighteen passengers in comfort. And in 1919, there was simply nothing like it on earth. At a time when aviators typically flew in open cockpits, the two pilots of the Lawson aircraft sat inside the aircraft behind floor-to-ceiling windshields that provided superb visibility. *Flight Magazine* described the radical new aircraft:

> *All the seats are of wicker construction, upholstered with green leather and provided with safety belts. They are secured to the floor, but are readily detachable. The interior of the cabin is finished in polished mahogany, and the floors are covered with carpet. The depth of the body is sufficient to allow one to stand up without stooping when walking through.*[46]

In its July 14, 1919 edition, the *Milwaukee Journal* reported, "The plane now nearing completion is equipped for daytime travel; seats for the passengers are inside the body, one at each window, one passenger to the seat with an aisle between. The machine is powered by two Liberty motors and is painted red and green."

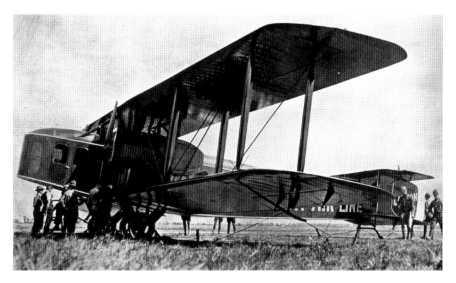

The first commercial airliner in the United States, the Lawson C-2 made headlines in 1919 for its daring long-distance test flight.

It was a new kind of aircraft (a word Lawson claimed to have coined), built to serve an industry that didn't yet exist.

The C-2 was built in a hall at the state fairgrounds, partially disassembled, then towed by a team of brewery horses to Milwaukee's first municipal airport (located at Currie Park in Wauwatosa), where it was put back together. On August 22, 1919, a large crowd gathered for the formal dedication of the big airplane. Most of them thought the ungainly craft would never fly. Then the airplane's two twelve-cylinder engines sputtered to life. One of the most remarkable adventures in aviation history was about to take place.[47]

The story begins back in 1908. Lawson, a former minor league baseball player and failed promoter of his own baseball league, became fascinated by accounts of the first powered flights and decided to launch a magazine called *Fly*. At the time, only a handful of men in America knew how to fly an airplane, but Lawson's new magazine capitalized on growing public interest and was a success.

In 1910, Lawson took his first ride in an airplane. It was a single-seater, and the pilot directed Lawson to sit on the wing, adding helpfully, "When we are going up lean forward so that you do not slide off backward, and when we are coming down lean backward so you do not slide off forward."[48]

Lawson, who did not slide off, greatly enjoyed the flight. Three years later, he took flying lessons and purchased a seaplane, in which he flew the thirty-

five miles from his home in New Jersey to a dock near his office in New York City, making sure newspaper reporters were on hand to write about the nation's first air commuter.

His publishing company ran into financial difficulties in 1916, which spurred Lawson to seek a new venture. In early 1917, when it became apparent the United States would be drawn into World War I, the Green Bay Chamber of Commerce invited him to visit the city and explore building a military aircraft factory.

With the backing of ten residents willing to risk $1,000 each on the endeavor, Lawson jumped into the airplane business. He rented a factory, purchased materials, hired a dozen engineers and mechanics and designed, built and flew a prototype biplane—and did it all in just four months.

That first aircraft, designated MT-1, was intended for training new military pilots. Lawson performed the test flight himself. Landing after an uneventful fifteen-minute flight, he told workers crowding around the aircraft, "Boys, any old woman that don't drink, smoke or chew tobacco ought to be able to fly the MT-1."[49]

Lawson and his workers built a good plane in record time. After a careful examination, a government tester told reporters the MT-1 was superior to any machine currently in use at aviation schools in the United States.[50] But no government orders were forthcoming by war's end in 1918. Lawson, ever optimistic, announced he would build "a great commercial airliner." His Green Bay stockholders, having lost money with Lawson's military trainer project, flatly refused additional funding.

Undaunted, Lawson turned his attention to Milwaukee. While experienced investors fretted over Lawson's spotty financial record, Milwaukeeans from the wealthy to the working class were swept up in his grand dream and purchased $500,000 worth of stock in the new firm.

"It was quite a whoop-de-do civic campaign," observed the *Milwaukee Journal* in a September 19, 1937 article.

Lawson called his engineers together in April 1919 and showed them a rough pencil sketch of a twin-engine eighteen-passenger airplane. At the time, the company didn't even have a factory. Even so, just four months later, the biplane was ready for a test flight.

In his book *Lawson, Aircraft Industry Builder*, Lawson neglected to mention the sketch became a reality largely through the efforts of his brilliant factory superintendent, twenty-three-year-old Vincent Burnelli, then embarking on a long and successful career in which he would be awarded sixty aviation patents.

Burnelli disliked the look of the Lawson airliner, calling it a "streetcar with wings." Also, it lacked one essential feature—a pilot.

Lawson wrote, "I wanted a better pilot than myself to take the airliner off of the ground and bring it back again. Several good pilots who had written for a position came to Milwaukee from distant points, but after looking over the new craft they left without wanting the job and with a look of pity in their faces for me."[51]

A professional ballroom dancer and pilot named Charles Cox heard about the plane and traveled at his own expense—and without an invitation—to apply for the job. Cox's brashness and complete confidence in the aircraft appealed to Lawson, so he decided to give him a chance. It was only much later Lawson learned that at time of his application, Cox had less than eight total hours flying time—and that in a single-engine aircraft.

With the airliner reassembled at the Milwaukee airport on August 22, 1919, Lawson spread the word among the crowd that he planned only to taxi back and forth to test the engines and control surfaces. In his memoirs, Lawson recalled that several people laughed and said it would never fly—that day or any other day.

Lawson wrote, "Well, as soon as that airliner began to move forward at 4:30 o'clock in the afternoon and the two 400 horsepower engines began to roar, and the wings began to lift, I could not resist the temptation of pushing the throttles wide open and, within a few seconds, it literally jumped from the earth into the sky in a manner that was both thrilling and satisfying."[52]

The first flight, with Cox and Lawson at the controls, lasted only a few minutes before a fuel line came loose and forced the plane to land. A week later, the same two men, accompanied by mechanics and engineers from the factory, were ready to try again.

"After we got into the air and I found everything worked smoothly, I told Cox to nose her south and 58 minutes later we landed at Ashburn Field, Chicago, a distance of 85 miles from Milwaukee," Lawson wrote. "As we arrived at sundown and nobody in Chicago expected us, there was but a half-dozen mechanics at the field when the airliner glided to the earth with the ease and lightness of a bird."[53]

Soon afterward, Lawson and his crew embarked on a record-setting 2,500-mile demonstration trip to the East Coast and back. Shrewdly inviting reporters from Chicago's leading papers to ride along, Lawson set off on the first leg to Toledo, 250 miles away.

In 1919, any flight could end unexpectedly, and this one would be no exception.

The Toledo landing field was too small for the big plane and covered by the remains of an arena built for a championship prizefight. Lawson and Cox circled a bit, then made a smooth landing on a farm pasture outside of town. The farmer and his wife, after recovering from their surprise, treated their unexpected guests to a huge meal.

The Lawson C-2 flew from Toledo to Cleveland with a fresh batch of reporters aboard and then from Cleveland to Buffalo. On arrival, a woman falsely claiming to be a reporter for a Buffalo newspaper asked to ride the next segment to Syracuse.

Approaching the tiny aero club flying field in Syracuse, Lawson backed off the throttle too early. The massive plane landed in the soft dirt of a cabbage patch short of the runway, its right wingtip striking the ground, skewing the aircraft around and sending it careening into a drainage ditch. It came to rest nose down and tail sticking up at a forty-five-degree angle.

Lawson recalled, "I didn't feel in any mood to study facial expressions but as I looked backward and slightly upward, I was surprised to see the lady reporter with a powder puff in one hand and a looking-glass in the other, busily engaged powdering her nose. Later on she told someone she did not know that anything unusual had happened, thinking that when the airliner went up on to its nose that was the usual manner in which it landed."[54]

There were no injuries and very little damage to the aircraft. After a week of repairs, the C-2 flew on to Long Island. Lawson spent several days basking in the glow of favorable media attention and taking local dignitaries up for short flights. On September 19, the Milwaukee airliner, with fourteen passengers aboard, flew to Washington, D.C., generating another wave of flattering newspaper articles. Passenger Felicity Buranelli told the *Washington Post*,[55] "The leather seats are comfortable and most of us sat throughout the entire trip. Occasionally one of the passengers would walk up and down the aisle. It was just as though we were floating through the air."

After a lengthy stay in Washington, the airliner started its homeward journey, intending to make a stop in Dayton, Ohio. Instead, the plane ran into severe storms over the Allegheny Mountains accompanied by an eighty-mile-per-hour headwind. With fuel running low, Cox spotted a field that could accommodate the big aircraft. As the plane descended, it was caught in a violent downdraft and stuck ground hard enough to blow out all four tires.

Once again, passengers and crew emerged without a scratch, but the damaged plane had to be dismantled and shipped by railroad flatcar to Dayton. Repaired and completely overhauled, the airliner flew

to Indianapolis, on to Chicago and finally arrived home in Milwaukee on November 14, 1919. It had been gone three months, flown 2,500 miles and safely carried four hundred passengers.

In the October 26, 1919 *Milwaukee Sunday Sentinel*, Lawson thundered, "Until recently the airplane has been of no commercial value. From now on, however, there will be commercialized air routes not only in this country but in many others, and the Lawson airplane will be the first to pave the way."

By early aviation standards, the demonstration had gone incredibly well. Lawson was in his element, bubbling with optimism and fantastic claims. He would, he said, establish a coast-to-coast service within six months with several intermediary stops using purpose-built aircraft for both day and night flying.

In September 1920, the government awarded Lawson Airline Company, a subsidiary of the aircraft manufacturing company, air mail contracts on three routes worth $687,000 annually. The contracts specified aircraft capable of hauling 1,500 pounds of mail, and Lawson was the only successful bidder. The company planned to carry passengers on the mail flights, adding still more revenue; 306 round-trip flights were planned per year on each route.

Looking back in a September 2, 1937 article, the *Milwaukee Journal* reported:

> *Sitting on top of the world in the knowledge that at last his dreams were coming true, Lawson laid on paper plans for building 100 airliners, of establishing air routes from coast to coast and from Texas to Canada....In 1920 he designed and built his second ship, which he called the Midnight Airliner. It was larger than the first, was powered with three motors and provided sleeping berths and a shower and lavatory for its 34 passengers.*

But behind the scenes, Lawson's dream was turning into a nightmare. An economic downturn made it impossible to attract the level of investment needed to fund his outsized plans. Production of the complex new airliner ran into delay after delay at the company's factory in South Milwaukee. More seriously, Lawson was forced to ask the government to cancel the air mail contracts.

As the weeks dragged into months with no aircraft emerging from the Lawson factory, shareholders began grumbling. Florence Roth Johnson, quoted in the April 2002 South Milwaukee Historical Society newsletter, recalled, "Many South Milwaukeeans, including my Aunt Rose, had invested heavily in this company and tension was high as they awaited the initial run. For many days prior to the takeoff day, the plane could be seen

taxiing up and down in front of the factory. Each day, the townspeople would wonder, 'Is today the day?'"

According to biographer Lyell D. Henry Jr., Lawson was given an ultimatum by stockholders: Get the new plane flying or resign from the company.[56]

On May 8, 1921, the Midnight Airliner lined up for takeoff on an improvised three-hundred-foot dirt runway next to the factory. (By comparison, Milwaukee's present-day Mitchell International Airport has a runway more than *nine thousand* feet long.) It is likely finances had become so tight the company could not afford the additional expense of dismantling the craft, towing it to the runway at Wauwatosa and assembling it there.

Lawson and pilot Clarence H. Wilcox revved up the engines, lumbered the length of the too-short runway and on into the deep soft earth of a freshly plowed adjoining farm field before struggling into the air. But the gigantic three-engine plane (its wingspan was longer than that of a Boeing 737) was moving far too slowly to gain altitude. To avoid hitting a farmhouse, pilot Wilcox banked the plane sharply, grazed an elm tree, then slammed hard into a telephone pole. The plane crashed seconds into its first flight.[57]

The aircraft was demolished, but Lawson and Wilcox emerged from the mangled wreckage unscathed. Lawson calmly ordered coffee and doughnuts delivered to the crash scene and told reporters he would soon have the aircraft repaired. In fact, the company was shattered as completely as its aircraft and closed its doors soon afterward.

The loss of the Midnight Airliner is especially sad because it was, in many ways, an advanced design and among the largest biplanes built to that time. Furthermore, it did leave the ground and was responding well to controls.

Had the Midnight Airliner taken off from a proper runway, Lawson's airline probably would have failed anyway. The optimistic entrepreneur was a full ten years ahead of his time. In the early 1920s, the science of safe, long-distance, all-weather flight was simply not advanced enough to support regular airline service.

At the same time Lawson was building the Midnight Airliner, another early aircraft maker—Boeing—had converted its Seattle factory into a furniture making operation in an effort to keep its doors open. In June 1921, a month after the crash in South Milwaukee, Boeing won a contract to build two hundred fighter aircraft for the U.S. Army Air Corps. A few years later, when America's airline industry finally got off the ground, it would be flying Boeing products.

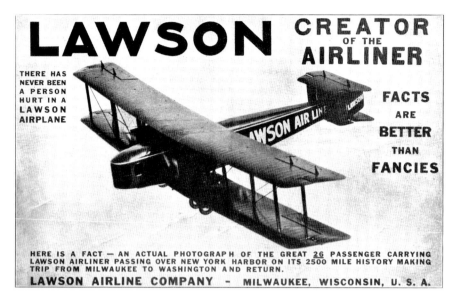

At a time when flying was risky, an advertisement touts the safety of Lawson's aircraft.

Alfred Lawson went on to found the Direct Credits Society, a program of economic reforms he devised, and later launched a quasi-religious philosophical movement called Lawsonomy. (Many Wisconsin residents will recall the large University of Lawsonomy sign that stood for many years along Interstate 94 near Kenosha.)

Lawson died in San Antonio, Texas, on November 29, 1954, at the age of eighty-five.

In an article published on July 22, 1955, the *Milwaukee Sentinel* wrote, "Alfred W. Lawson was the Jules Verne of the 20th century, the Wright of commercial aviation, the Edison of flying."

The Lawson factory stood until a few years ago. It was torn down to make way for an apartment complex. Today, people play golf on the site of the old runway at Currie Park. Its replacement, Mitchell International Airport, hosts hundreds of flight operations each day. But in 1919, Alfred Lawson built America's first airliner in Milwaukee and successfully demonstrated it on an amazing long-distance tour.

And as the company's advertisements noted, no one was ever hurt in a Lawson airplane.

12
THE ICE WAR

In the winter of 1900–01, a pitched battle erupted on the frozen Milwaukee River above the North Avenue dam between enraged ice harvesters and the equally violent crew of a steam-powered launch. The newspapers called it "The Ice War."

On a section of river that has witnessed many strange things over the years, the ice war was perhaps the strangest. If the riot-on-ice aspect wasn't odd enough, the fighting was accompanied by jaunty music provided by the steamboat's brass band.

The ice war lasted six weeks, and it was witnessed by hundreds of spectators and heavily reported in the city's newspapers. Onlookers and reporters thought it hilarious, but real injuries were sustained, working men had their livelihoods threatened and it all had to do with ice.

To understand why these warmly dressed men were punching one another on the surface of a frozen river you need to know why the lost industry of ice harvesting was once worth fighting over.

The ice business was born in the earliest days of the city, when a man named Henry "Ice Bear" Kroeger started cutting one-hundred-pound blocks of ice from the harbor in winter and storing it in a heavily insulated icehouse for resale in the summer months. Butchers were his biggest customers.

By the winter of 1892–93, the city was home to 10 wholesale ice dealers with a total winter employment of at least 1,200 people and an annual harvest of 300,000 tons—and that figure didn't include ice cutting and

Crew members struggle to free the ice-bound *Julius Goll* during the 1901 "Ice War" on the Milwaukee River. *Courtesy of the Milwaukee County Historical Society.*

storage operations conducted by the city's breweries, generally another 50,000 tons.

Increasing water contamination from the growing city gradually shifted the ice business northward up the Milwaukee River. By 1900, ice harvesting took place at several locations along the upper river and on many area lakes.

Milwaukee was a good-sized city by then, with a population of 285,000 and a major industry of brewing, storing and transporting lager beer. Lager must be kept cool, requiring ice by the ton. Plus, just about every one of the city's many homes had an icebox to keep food cold.

It was easy to keep food in winter, obviously, but summer required frequent visits from the iceman, who delivered a 25- or 50-pound block of ice to customers' insulated tin-lined wooden iceboxes. Homeowners usually contracted with an ice company by purchasing coupon booklets in advance (at the turn of the twentieth century, 750 pounds of ice cost two dollars—about two days' wages for a laborer), handing over a coupon each time ice was delivered. Homeowners benefitted from locking in a set price, and the iceman didn't have to handle money.

Ice was a huge business in the state, and Wisconsin Lakes Ice Company, based in Milwaukee, dominated the market. The company was founded in 1849 by German immigrant John Kopmeier. By the turn of the century, Wisconsin Lakes employed 225 teamsters, all neatly dressed in dark-blue uniforms with bright brass buttons. The company owned more than five hundred delivery horses.[58]

At its height, Wisconsin Lakes owned twenty icehouses across southeastern Wisconsin, including several large operations on the Milwaukee River that seasonally employed hundreds of laborers at one dollar a day, paid in cash each night. Many workers, especially Polish immigrants in the Riverwest neighborhood, depended on ice cutting to get their families through the winters.

The Wisconsin Lakes Milwaukee River icehouses included a pair on the west bank at North Avenue, one south of the bridge and the other north of the bridge, and a third a few blocks farther north, atop the bluff near the foot of Center Street. The company also maintained an icehouse on the river south of Bradford Avenue on the east bank.

Once the ice reached a thickness of eighteen inches, workers shoveled snow off the ice field—the section of frozen river adjoining the icehouse—then carved deep grooves in the ice with horse-drawn plows in an exact grid pattern. Workers moved in with saws, long chisels and steel-tipped pikes and systematically broke off sections and floated them to a conveyor, which carried the ice blocks through a rotating planer. The planer milled off the surface, where most of the dirt and debris were to be found.

From there, the now uniform blocks entered the cavernous interior of the icehouse, where more workers skidded them neatly into organized stacks, spreading heavy layers of insulating straw, wood shavings or sawdust as they went. Ice could be stored for two or three years this way.

Work was suspended when it got too cold. Sub-zero temperatures froze the ice channels as fast as workers could open them.

Now the plot thickens. An upstart firm, the Pike & North Lakes Ice Company, built a large icehouse on an area lake. It had substantial financial backing and experienced icemen in control and intended to be a major player in the Milwaukee market dominated by Wisconsin Lakes. It planned an advertising campaign touting the purity of its lakes to capitalize on public concerns about ice from the increasingly dirty Milwaukee River.

There was, however, a small strip of land between North Lake's new icehouse and the railroad siding. Someone, probably acting under the direction of the Wisconsin Lakes Company, bought this land and refused

to grant North Lakes permission to cross the property, which it had to do to ship out its ice.

One day in winter of 1900–01, the Wisconsin Lakes Ice Company had three hundred men at work harvesting ice on the upper Milwaukee River when a steam-powered river launch, the *Julius Goll*, appeared, its hull covered with boiler plate and equipped with an ice-breaking prow. To the cheerful accompaniment of its onboard brass band, the launch proceeded to steam up and down the river, smashing up the Wisconsin Lakes ice fields.

The Wisconsin Lakes Company was certain the North Lakes firm hired the boat, but the captain of the *Julius Goll*, a man named Biggs, told reporters he was trying to establish an off-season river excursion service between the North Avenue dam and the Blatz Park beer garden, two miles upstream. Hence, he added, the reason for the band.

Historian Lee E. Lawrence described the scene:

> *The band played on, but the husky youths on board were far more than excursionists. They fought off the attacks of the men of the Wisconsin Lakes Company, pried the vessel free when it stuck on ice too thick to be borne down and broken by the special prow, cut heavy strands of barbed wire strung from bank to bank, warded off heavy timbers studded with spikes launched by the defenders, and made patches when their armored vessel was holed. This went on for six weeks whenever the river re-froze. No more ice was cut.*[59]

On Sunday, January 20, 1901, the battle reached a fever pitch to the delight of nearly one thousand spectators gathered on the North Avenue Bridge and both banks of the river. Ice company employees tried various obstructions to block the little steamer, including stringing a line of roped-together rowboats across the river and protecting the edges of the ice fields with wooden beams, but nothing seemed to stop the *Julius Goll*. A squad of police marched onto the ice to prevent an all-out brawl between the crew of the boat and ice company employees.

The *Milwaukee Journal* reported the events in its January 20, 1901 issue, adding an ominous note: "About 200 Poles whose livelihood depends on the harvesting of the ice, are becoming aroused over the work of the *Goll*. Some of the representatives of the ice company fear that they are liable to become vicious over the matter and then they will take the affair into their own hands."

In the early morning hours of Monday, January 21, the little steamer collided hard with a thick shelf of ice, opened a hull seam and had to call

it quits. However, the boat had done so much damage that the paper said it was doubtful any more ice could be harvested that season. On April 5, 1901, the *Journal* concluded,

> The ice is all gone and there is nothing to fight about, so the famous "ice cases" have been dismissed in police court by mutual consent. During the excitement on the river, a hole was punched in the "battleship" Julius Goll, *large quantities of ice cut by the Wisconsin Lake Ice Company were destroyed*, "Admiral" Biggs got a broken arm, and the adherents of both sides had numerous cold baths and bruises distributed among them.

In the fall of 1901, the North Avenue dam opened to draw down the level of the river to facilitate sewer construction along the west bank. The owners of the Wisconsin Lake Ice Company used the occasion to reshape the shore edge to ease ice harvesting. But a newspaper account added an ominous note:

> At the same time, the owners of that redoubtable fighting ship, the steamer Goll, which last year established an excursion route above the dam and incidentally broke up a large quantity of ice which was usually stored by the Wisconsin Lakes Ice company, are expressing some concern at the possibility of the water remaining too low all winter for the excursion business. In the meantime many people who were entertained by the quarrel between the owners of the Goll and the Wisconsin Lakes company last winter are interestedly awaiting developments.[60]

A truce was established, but the threat of renewed ice wars only really ended in 1904, when the Pike & North Lakes Ice Company was absorbed by Wisconsin Lakes. Its backers were said to have lost $100,000 in the failed venture—a vast fortune in those days.

Wisconsin Lakes's last natural ice harvest was in 1923. As the river became more polluted, the company switched to manufacturing machine-made ice. As late as 1940, the company was still operating 212 ice routes in the Milwaukee area. In time, the company added coal and fuel oil deliveries and operated twenty-four gas stations under the Hometown name. It was headquartered at 1518 East North Avenue, just two blocks from the battlefield of 1901. In its September 19, 2005 issue, the *Milwaukee Business Journal* reported on the sale of Hometown's 150-year-old ice business to a Canadian firm, Arctic Glacier, and the closing of its last remaining Milwaukee ice plant.

13
EVINRUDE TEST FACILITY

There are reminders of the past everywhere along the upper Milwaukee River. For example, you can still see traces of the testing facility of Evinrude outboard motors on the west side of the river between East Wright and East Meinecke Streets. The narrowing of the Milwaukee River after the opening of the North Avenue dam left the test facility high and dry.

If these pieces of aged concrete could speak—well, they might tell you about the time Ole Evinrude made an ice cream run.

Ole Evinrude was a child in 1882 when his family immigrated to America from Norway. The family settled in Cambridge, Wisconsin, where Ole was educated in a one-room schoolhouse. By third grade, it is said, he could solve all the equations in the school's eighth-grade mathematics textbook—and soon afterward quit school.[61]

When Evinrude turned sixteen, he signed on as a machinist apprentice in Madison and then worked for a series of firms, including a steel mill, a maker of electrical devices and a company manufacturing industrial engines. At age twenty-three, Ole came to Milwaukee to work for the Edward P. Allis Company as head of the pattern department.

In his spare time, he built an experimental gasoline engine in his boardinghouse and met Bessie Cary, a young woman who lived a few doors down. Photos of the couple show Ole, a shyly smiling giant of a man, towering over the diminutive Bess.

One hot August day, Ole and Bess picnicked with friends at Okauchee Lake. Bess mentioned that ice cream would taste good on a day like this, and

The concrete footings of the Evinrude outboard motor testing facility can still be seen on the west bank of the Milwaukee River.

that was all the encouragement the kind-hearted Ole needed. With the sun beating down and the temperature above ninety degrees, he rowed across the lake, found a store and rowed back. It was a four-mile round trip, and he returned, hot and blistered, with an unappetizing carton of melted goop.[62]

Bess and their lunch companions found this hilarious, but Ole's thoughts were elsewhere. He was wishing somebody would invent a motor able to clamp to a rowboat. Then he thought, "Why don't I do it?"

Bess and Ole married in 1906. He tried launching an automobile manufacturing company. When that failed, he opened a pattern-making shop, which thrived. With his business firmly established, Ole finally had time to tinker with his prototype outboard motor.

His first attempt, a one-and-a-half-horsepower single-cylinder outboard, was patented in 1907. It greatly amused Bess, who thought it looked like a coffee grinder. Two years later, Ole built an improved working prototype. Encouraged by a successful test run on the Kinnickinnic River, he ordered enough parts to make twenty-five outboard motors. A few weeks later, one of

his employees borrowed the prototype for a weekend trip to Pewaukee Lake. He returned with the engine—and ten paid-in-advance orders.

Ole didn't invent the first outboard motor—a handful of companies were already marketing them—but Ole's practical and well-made engines gained widespread acceptance and laid the groundwork for the entire outboard industry.[63]

Evinrude was in business, but there was a problem. Ole could design products, supervise a factory and keep production flowing smoothly, but he disliked keeping books, dealing with correspondence and the myriad other details involved in running a company. That's when Bess stepped in as office manager. She wrote the company's first ad ("Don't row! Throw the oars away! Use an Evinrude motor!"). She wrote and mailed circulars. Aware of the mistrust of women in business in that pre–World War I era, Bess signed the company's correspondence "B. Evinrude."[64]

With Bess running the business and Ole watching over the factory, orders by the tens, the hundreds and, soon, the thousands rolled in. The company quickly outgrew its first factory on Lake Street and moved into a three-story building on Reed Street as employment reached three hundred.

In 1913, Evinrude sold 9,412 outboard motors. Many corporate twists and turns followed, including ownership changes, the founding of a new company and finally a multi-company merger in 1929, which established Ole Evinrude as president of the largest outboard maker in the world.[65] The merger also allowed Bess, who had been in frail health for some time, to retire.

The merged company, Outboard Motors Corporation (OMC), consolidated manufacturing operations in a plant north of the intersection of Twenty-Seventh Street and Capitol Drive. The factory had a capacity of four hundred motors a day in 1929 and employed 750. But the arrival of the Depression would see employment cut to a minimum, and those few workers limited to sixteen hours a week as OMC struggled to attract orders. Ole stopped drawing a salary and used his personal fortune to keep the company afloat.

Bess Evinrude died in 1933 at the age of forty-eight. Ole never emotionally recovered from the loss of his wife and died just fourteen months later.

Their son, Ralph, age twenty-seven, took over the multi-brand recreational boating empire now known as Outboard Marine Corporation The company was a major defense contractor during World War II, building outboards for the military as well as aircraft engine superchargers. The end of the war unleashed pent-up demand for recreational goods, and OMC's family of brands couldn't build boats and engines fast enough. Outboard Marine produced 262,000 outboard motors in 1947, equaling the combined

production of the fourteen other outboard makers in the United States. Production topped 400,000 by 1960, and OMC operated plants across the country and in Canada and Belgium.

At its peak, OMC's Evinrude division employed 1,800 people in Milwaukee. Among its various machine shops and factories was the modest test facility on banks of the Milwaukee River. Here, where the river was at its widest above the North Avenue dam, company engineers methodically turned pre-production mock-ups into new products. And it was here many of Evinrude's innovations took to the water—the first electric-start outboard, the first rubber mounting system, the first forty-horsepower engine, the first V-4 outboard, the first angled-drive weedless propeller and an exhaust system that cut motor noise by 50 percent.

The test facility was located on North Bush Lane. This road, now gone, once extended north from under the North Avenue viaduct to access several properties along a wide, level section of the west bank of the river. A 1910 map shows two houses on Bush Lane, four structures for boat storage and a boat repair shop.

In 1957, Evinrude constructed a much bigger boathouse and test station near the harbor entrance at the confluence of the Milwaukee and Kinnickinnic Rivers. This section of waterway didn't freeze in the winter because car ferries operating nearby kept the ice broken up. (This facility was acquired by the state in the 1980s and is now a public boat launch.)

The upper river facility continued to operate for a time but eventually closed. In 1966, Evinrude donated the property, about six hundred feet of river frontage, to the county for park purposes.[66]

Ralph Evinrude died in 1986. A few years later, the company stumbled into a crisis. The federal government singled out two-cycle small engines, including most outboard motors, as significant polluters. As Evinrude struggled to clean up its engines, Japanese manufacturers entered the U.S. market with relatively clean-burning four-cycle outboards.

In December 2000, Outboard Marine filed bankruptcy and laid off seven thousand workers in plants across the country. It was the end of the company as a major employer in Milwaukee but not the end of Evinrude. In 2001, Bombardier Recreational Products acquired the brand and today makes Evinrude outboards in Sturdevant, Wisconsin, including a low-emissions three-hundred-horsepower V6, which the company says outperforms any engine in its class while using the least amount of fuel.

If Ole could see it, he might say, "Now that's what I'm talking about! Who wants ice cream?"

Bush Lane is lost in the weeds now and only rubble remains of the old test facility, but fifty years ago, Wisconsin was the industry leader in outboard motors, with five major manufacturers producing half the motors sold in the United States and the upper Milwaukee River hummed with the sound of Evinrude motors.

14

THE LITTLE ENGINE THAT COULDN'T

Wisconsin has led the outboard motor industry ever since Ole Evinrude fired up his prototype engine in 1909. In the years following World War II, Wisconsin outboard makers manufactured half the motors sold in the United States. With the easing of wartime manufacturing restrictions in 1945, a new company on Milwaukee's near north side was ready to earn a place in a market dominated by established brands.

Metal Products Corporation was late to the game but confident its lightweight and innovative Flambeau outboard motor would be a hit as the country turned its attention from war to recreation. The former outboard factory still stands at 245 East Keefe Avenue.

George L. Kuehn led the company as president and treasurer. A former boat racer (he won championships every year from 1932 to 1941), Kuehn understood marine engines and had ideas for making them better. With support from his father, former Milcor Steel president Louis Kuehn, George partnered with engine builder Edward Engelhorn and established Metal Products Corporation in 1941.[67]

The outbreak of World War II put its planned line of outboards on hold as the company turned to military production. Leo Kincannon, who had designed outboard motors for two other companies, joined the new firm in 1943.

Finally, in late 1945, the company announced production of its first two models. Sold under the Flambeau brand name, the die-cast aluminum

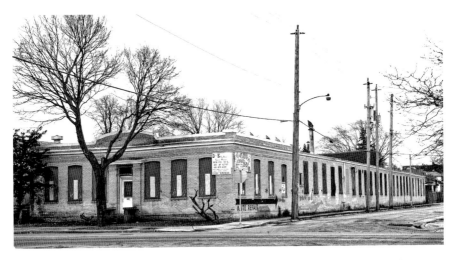

This building formerly housed Flambeau Motors, a maker of outboard engines. The company made interesting, if quirky, lightweight aluminum motors.

motors were available in two-and-a-half-horsepower and five-horsepower models. The motors were lightweight (the five-horsepower model weighed just thirty-two pounds) and had interesting features, including built-in carry handles, an improved carburetor and a new way of protecting the propeller from underwater damage.

The company had a product, an eager public—and no end of trouble getting production under way. It spent most of 1946 struggling to keep any semblance of manufacturing going at a time when raw materials were scarce.

Matters improved considerably in 1947. When a reporter from the *Milwaukee Sentinel* visited in April of that year, the company had already made two thousand motors. However, the newspaper reported, a shortage of parts meant the production line—capable of making two hundred motors a day—was turning out just seventy-five. "If it isn't cartons, its grey iron castings," Kuehn told the reporter. "And now and then we're short of magnetos, too."

He also announced plans for a ten-horsepower engine. It was never made. In fact, when production ceased ten years later, around 1957, Flambeau was still making its two original models. Metal Products Corporation likely never achieved the sales volume necessary to support the development of a new engine model.

Flambeau outboards have an unusual design. They are made from two large aluminum castings sandwiched together with the cylinders, pistons

and other moving parts contained inside. This clamshell design, Kuehn told the *Sentinel*, meant his engine was light, easy to produce and simple to service.

In retrospect, probably only one of the three attributes he cited is true: Flambeau engines are light. The extremely precise aluminum castings must have been difficult to make. Additionally, the quirky design turned otherwise simple repairs into an ordeal.

According to Oddjob Motors, a website for small engine enthusiasts, "Based on the number of (now antique) Flambeaus that have turned up with internal sealing problems, there can be no doubt the motors had reliability issues."

On the other hand, the same website notes the $2\frac{1}{2}$-horsepower Flambeau it tested was "amazingly powerful…closer to $3\frac{1}{2}$ or 4 horsepower. It is also reasonably smooth and quiet. It is a bizarre design and very tough to work on, but it sure runs great!"[68]

Another factor in Flambeau's downfall may have been the market dominance and aggressive marketing practices of Outboard Marine, the maker of Evinrude and Johnson outboards. Outboard Marine was producing more outboard motors—and making more money—than all its competitors combined.

In 1951, the Federal Trade Commission investigated Outboard Marine's practices and—after five years and 1,692 pages of exhibits and testimony—found the company used its marketing leverage to unfair advantage by requiring an Evinrude or Johnson dealer to carry only that brand's motors and no other. A retailer wishing to sell Johnson outboards could not also sell, for example, Flambeau.

Outboard Marine salesmen visited each franchise dealer in their territory once a year. In addition to answering service questions and explaining the features of new models, the company representatives were secretly charged with making sure no other brand was being sold.

The FTC cited several memos from salesmen reporting various dealers found in violation of this policy. In a typical—and rather ominous—memo, an Evinrude sales manager wrote to a company field representative to report the outcome of a conversation with one dealer, "[The dealer] has agreed to go along with us and knows what will happen if he figures otherwise."[69]

Outboard Marine defended its dealer exclusivity requirement. Dealers, it noted, generally prefer to sell one brand. It simplified parts stocking and made life easier for their service technicians. Additionally, both Evinrude and Johnson offered a broad range of engine sizes. Most competitors, including Flambeau, offered only low-horsepower outboards. Moreover,

Outboard Marine offered far greater dealer benefits than its competitors, including company-paid training for dealers and service personnel. Additionally, it spent more on advertising its outboards than any other competitor and, in some years, more on advertising than all its competitors combined.

The FTC ruled, "[Outboard Marine], as one of its witnesses put it, is the General Motors of the outboard industry; the oldest and best according to its proof. Its motors are prestige products, the most widely advertised and sought-after. Its dealerships are apparently avidly sought after and its products find a ready and profitable market. The commercial balance…is so lopsided that rarely does a dealer cancel."

At the same time the outboard market expanded rapidly, the FTC noted, competitors registered significant sales declines. Scott-Atwater Company reported fewer dealers in 1951 that it had had when it entered the market in 1946 despite considerable investment and expansion in its line of outboard motors.

The hearings must have been contentious. The vice president of sales of Martin Motors testified his company's decline in sales was entirely caused by Outboard Marine's exclusive dealer agreements. In response, Outboard Marine's representative called the Martin vice president "a peddler of pots and pans"—Martin Motors being a division of National Pressure Cooker.

In 1956, the government ordered Outboard Marine to grant Johnson and Evinrude dealers the ability to sell other outboard brands. The ruling came too late to help Flambeau. Hampered by an unusual design and an inability to access the national market, Flambeau outboards are now a footnote in Milwaukee's industrial heritage.

15

THE SWEETEST STORY

Although its reputation has more to do with brewing than bonbons, Milwaukee once ranked among the top five candy-producing cities in the United States. Even in the bleak years of the Depression, the city's sixteen candy factories employed two thousand people with annual sales of $7.8 million.

One of those firms, the George Ziegler Candy Company, was founded before the Civil War and lasted into the 1970s. Its annual production averaged twelve million pounds, the *Milwaukee Journal* noted in a 1920 article. That's about twenty tons of candy produced each working day.

This is a story about chocolate. And a fire hose. But mostly chocolate.

Did you know Milwaukee's municipal court once ruled one has a right to turn a hose on workers who pile streetcar rails in front of one's business?

> *There was a flurry of excitement in the municipal court this morning when Frank Ziegler was arraigned on a charge of disorderly conduct. The facts were that the employees of the Milwaukee Street Railway company were unloading rails on East Water Street yesterday afternoon and piled some in front of the Ziegler candy factory in such a manner that the business of the firm was interrupted with, as its teams could not back up. Frank Ziegler remonstrated, and asked that the rails be placed in a different position. The demand was not complied with, and Mr. Ziegler turned the hose on the streetcar men, drenching them thoroughly. Officer Monahan was called on, and arrested Mr. Ziegler on a charge of*

Twenty tons of candy were made each day in this seven-story building on West Florida Street, the former home of George Ziegler Candy Company.

> *disorderly conduct. After hearing the testimony, Judge Wallber discharged the defendant, holding that it was one of those cases in which a man was justified in protecting his property by summary process, and that the employees of the railway company had no right to place obstructions in front of a business house against the owner's protest.*[70]

Frank Ziegler was a second-generation candy maker. His father, George, founded the family business in the years immediately before the Civil War—mostly because he had enough money to buy a barrel of sugar.[71]

George's family had immigrated to the United States from Germany in 1845 and settled on a farm in Dane County. Young George didn't care for farming and moved to Milwaukee to learn the leather working trade. After a three-year apprenticeship, he went to work for the Bradley-Metcalf Shoe Company.

In 1851, George married Barbara Boll. Her brothers, John and Andrew Boll, were out-of-work candy makers who had moved back in with their parents. George had saved a little from each paycheck. It was enough to buy

a barrel of sugar and put his brothers-in-law to work. They started making candy in the kitchen of the Bolls' home at Thirteenth and Vliet. The father of the Boll boys, a tailor, helped out by calling on local merchants and urging them to stock the candy.[72]

The Boll brothers proved to be excellent candy makers, and their father seems to have been an unstoppable candy-selling machine. The new company grew rapidly. For a time, George continued to work at the shoe factory, keeping an eye on the business end of things in his spare time and occasionally dipping into his savings when the new company needed capital.

Soon, orders were pouring in faster than they could be filled, and Ziegler quit his factory job. On January 11, 1861, the firm of Boll Bros. & Company was established. In 1865, the candy company moved into a building on Third Street, then moved again to a building on Wisconsin Avenue. One of the brothers left in 1868, and the firm changed its name to Boll & Ziegler. In 1874, George Ziegler brought out the remaining partner and continued under his own name.

One by one, George Ziegler's five sons joined the business. Frank, that nemesis of streetcar workers, joined the company at age eleven as errand boy. He worked his way up through the ranks as candy maker, buyer, plant superintendent, vice president and president.

A fire destroyed the factory in 1882, and although the company quickly resumed operations from a new location on East Water Street, the nervous strain of rushing the new factory into production severely undermined Frank Ziegler's health. In 1887, he took an extended leave of absence to tour abroad. After his return, he was elected vice president and superintendent of the company. On his father's death in 1904, he became president.

During Frank's tenure, he turned a small company with forty employees into one of the largest candy makers in the Midwest—and one of the most innovative. It was the first to offer a chocolate bar containing peanuts. Unimaginatively named the Milk Chocolate Peanut Block, it was delivered to merchants in a giant slab. When a customer placed an order, a clerk would break off a piece.

In 1907, the company built a 112,000-square-foot, seven-story factory at 408 West Florida Street. In 1920, the company added a 72,000-square-foot addition. The candy factory had some unusual features, including adjacent and identical staircases—one for men and the other for women.

In 1911, after a bit of trial and error, Ziegler perfected a way to mold and wrap individual bars. The Fox Trot Bar was the first to be marketed

under a distinctive name. The company also introduced the chocolate and peanut Ziegler Giant Bar. It was the first candy maker in the state to manufacture marshmallow, and the firm also invented Candy Raisins, a regional favorite for many years.

Frank died in 1939 at the age of eighty-three. He was the firm's chairman of the board at the time of his death, having worked for the company for seventy-two of its seventy-eight years in operation.

With a new generation, Joseph E. Ziegler, at the helm, the company continued to turn out tons of candy each day from its Florida Street factory. In 1951, the company mailed 7,500 Giant Bars to wounded Korean War veterans recovering in overseas hospitals. The City of Milwaukee was one of its customers in those years, purchasing Ziegler Giant Bars at a steeply discounted price to supply Halloween programs for youngsters. In 1960, for example, 365,000 bars were purchased at a cost of $9,836.

The George Ziegler Company remained in operation for more than one hundred years, but all things must end. In 1971, the company was sold to an investment group. Three years later, it was out of business.

Candy making is no longer a major industry in Milwaukee, but Wisconsin is still the fourth-largest candy-producing state, with $850 million in annual sales in 2015 and more than two thousand employed in the industry.

And you can still buy a Ziegler Giant Bar. In 1990, Bill and Mary Ziegler, the fifth generation of Ziegler candy makers, opened Half Nuts, a candy store in West Allis. Among a range of other products, the store makes and sells Giant Bars using the original recipe and the original molds.

16

GRENADES AND UNDERWEAR

A few months after the United States entered World War I, Milwaukee investors established a company to make munitions, built a factory along the Milwaukee River in Glendale and hired an all-female workforce. A complication immediately arose. As author Jeffrey L. Rodengen noted, "Long Victorian-style dresses were serious hazards, since they could become caught in rotating machinery and belts. Women took to wearing 'bloomers' pants-like garments originally intended as undergarments."[73]

Many Milwaukeeans fought the Kaiser. The women of Briggs Loading Company did so in their underpants.

The government soon took notice and ordered coveralls be issued to the workers, ending an amusing footnote to an otherwise deadly serious business.

The Briggs Loading Company was incorporated on May 7, 1918. The company was an offshoot of Briggs & Stratton, which had been founded in Milwaukee in 1908 by Stephen Briggs, an electrical engineer, and Harold Stratton, a grain merchant. Just nine days after its incorporation, Briggs Loading Company secured a contract to assemble one million Type VB rifle grenades and detonating fuses. More contracts followed.

Other companies produced the materials for Briggs to assemble. Both International Harvester and Cutler-Hammer had contracts to produce rifle grenades and probably supplied raw castings to Briggs. At the time, Newport Chemical operated a three-hundred-acre plant on the shores of Lake Michigan in Oak Creek producing ingredients for high explosives.

A woman mills munitions primers during World War I. Women did similar work at the Briggs Loading Co. in Milwaukee. *Courtesy of the Library of Congress.*

The women at Briggs cleaned the parts, packed the casings with explosives, added fuses, varnished and painted the grenades and packed them for shipment.

Although Briggs & Stratton owned a large factory downtown, the new venture was located far to the north in hastily built wooden buildings opposite the north end of today's Estabrook Park. Nearby quarries dug by the Milwaukee Cement Company provided the company with a safe place to test munitions. The primary reason for the out-of-the-way location may have been fear of an accident involving high explosives—bad enough in the remote location but far worse in the middle of the city. It was a real concern, for the work was quite dangerous. In 1916, a munitions factory explosion near Leeds, England, killed thirty-five women.

Happily, the Milwaukee plant avoided serious accidents while maintaining an extraordinary rate of production. In just eighteen months, the woman assembled 5.4 million grenades.

On November 11, 1918, Germany signed an armistice, ending a conflict that had cost 17 million lives, including those of 116,700 Americans. William Howard Taft happened to be in town on a speaking engagement

when the news reached Milwaukee. A reporter roused the slumbering Taft by bursting into his hotel room at 4:00 a.m. and shouting, "The war's over!" The three-hundred-pound former president sat up in bed and replied, "You must excuse me not knowing a thing about it. I sleep like a bear."[74]

Residents poured into the streets in a spontaneous outpouring of joy. According to the November 11, 1918 *Milwaukee Journal*, an impromptu parade took place and the women of Briggs Loading Company formed one of the groups marching through the city, holding signs with such slogans as "We filled the grenades."

The *Journal* noted, "They wore the government assigned safety pantaloons and were loudly cheered along the line of march."

17
ELINE'S CHOCOLATE

From its massive purpose-built factory to the staggering amount of money lost in its eight-year history, everything about Milwaukee's Eline's Chocolate & Cocoa Company was outsized.

The venture was launched by the Uihlein family, the owners of Jos. Schlitz Brewing Company. It's not easy to go from Beer Baron to Count Chocolate but they certainly gave it a good try. The family hired experts, built a sprawling state-of-the-art factory on Port Washington Road in Glendale, hired an army of workers and launched an ambitious marketing campaign.

Eight years later, it was out of business. Today, only a few buildings remain of the Eline complex—monuments to a mistake.

In 1919, transitioning from beer to bonbons made sense. The thirty-sixth state approved the Eighteenth Amendment at the beginning of that year, making Prohibition the law of the land and starting the clock ticking. On January 17, 1920, one year after ratification, it would become illegal to manufacture, sell or transport alcoholic beverages in the United States.

The owners of Schlitz needed a replacement business as comfortably profitable as brewing. The answer, or so it seemed, was right at their doorstep. With sixteen established firms employing two thousand residents, Milwaukee was then a major center of candy production. Most of these companies started very small—the Ziegler Candy Company, for example, made its first products on a kitchen stove.

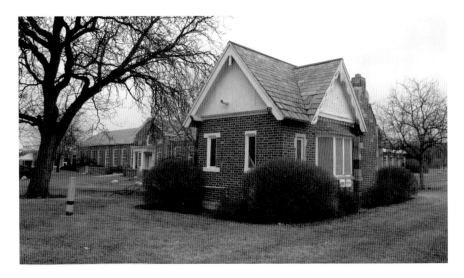

Above: The factory's gatehouse still stands. The ornate little building is now used for storage. The former Eline office building is just beyond.

Right: The gatehouse's hand-carved details hint at the past short-lived glory of the Eline chocolate factory.

With practically unlimited capital at its disposal and little time before the onset of Prohibition, the Uihlein family decided to enter the market on a huge scale.

"Here is the ideal location," Joseph E. Uihlein Sr., president of the newly formed Eline's Chocolate Company, said in 1919. "Wisconsin is the greatest dairy state in the union and good fresh milk is the one requirement for a chocolate manufacturer. We have made plans for unlimited expansion."[75]

Looking back years later in an interview with the *Milwaukee Journal*, his son, Joseph Jr., said, "My father had the theory that with beer and liquor cut off, people would turn to chocolate. Instead of starting in a small way, the family built a tremendous plant."

"Until then, my father had tasted nothing but success all his life,"[76] he added. That would soon change.

But what a factory he built! Willy Wonka had nothing on Joseph Uihlein. Newspapers wrote of lobbies paved with marble imported from Italy, fireplaces in every office and a garage modeled after Apethorpe Hall in England. The entrance pillars were inspired by those at Harvard University.

And then there was the gatehouse.

A company booklet from the 1920s, titled the *Gate to Eline*, describes what was essentially a guardhouse as a vision of Old World charm: "If you are afoot you will enter through the sidewalk gate and notice the hand-hewn timbers of the old English Gatehouse, tell the time by the quaint, old sundial…or perhaps be greeted by the doves from their cotes. Or, if you come by motor, the Lodge Keeper will come at your call to spread the hand-wrought iron gates, copies of the celebrated gates at Drayton House, England."

As early as 1924, there were rumors the Uihleins were looking to sell the business. But just two years later, they hired four hundred salesmen, retooled the factory to the tune of $1 million and added a line of hard candies. In the end, it was simply more money down the drain. Two years after that, in 1928, the company was liquidated.

Published accounts focused on the company's missteps. An Eline's Almond Bar might or might not contain almonds, gum balls sometimes shattered when dropped and the company briefly used a food-grade lubricant made from fish oil on its packaging machinery, only to discover it made the chocolates taste fishy.[77]

These mishaps made for amusing reading, but the real problem was not its products, it was the ocean of red ink into which the company was rapidly sinking. The family invested a fortune to muscle its way into a highly competitive business and failed to capture a significant share of the market. The factory lasted less than ten years and burned through a reported $17 million.

The English gatehouse with its hand-hewn timbers still stands near the intersection of North Port Washington Road and West River Woods Parkway. Now used for storage, the building's intricate details are worth a close look. Eline's office building, just to the north, also survives.

The four-story factory was a more utilitarian affair: a 1920s-style brick and reinforced concrete structure with walls of multi-paned windows. It survived the collapse of the candy company and would house an ammunition plant in World War II. It was demolished in the 1970s.

Prohibition ended in 1933, and the Uihleins returned to brewing and, presumably, tried very hard to forget about chocolates.

18
DEAF WORKERS AIDED WAR EFFORT

In 1942, at the height of World War II, the federal government contracted with the U.S. Rubber Company to build and operate the Milwaukee Ordnance Plant, producing .50-caliber machine gun ammunition.

Leasing the factory complex that formerly housed the failed Eline Candy Company operation on North Port Washington Road, U.S. Rubber set about converting it to ammunition production. Time was of the essence, and cost was no object. The company spent the present-day equivalent of $302 million to equip the factory and hired five thousand workers to operate it twenty-four hours a day, six days a week.

As it neared the end of its first year in operation, Milwaukee was shipping out finished cartridges at the rate of twenty to twenty-eight boxcar loads each week. In its September 29, 1943 issue, the *Milwaukee Journal* shared a startling statistic: "Enough cartridges have been made at the plant to kill everyone in the United States."

But that first year of production was also the last.

By late 1943, having amassed huge stockpiles of .50-caliber ammunition, the government announced plans to wind down production at the plant. It had been, as the *Journal* noted in a November 17, 1943 editorial, an extraordinary year. "The Milwaukee Ordnance Plant, even before full production, had turned out more .50 machine gun ammunition than all the plants in the country turned out in World War I. It is good ammunition. It is stacked high, in this country and near all fronts and future fronts."

The ordnance plant's former hiring office, originally part of the Eline Chocolate works complex, is now Waste Management's local headquarters.

The paper added, "It was a costly year. A big job had to be done in a hurry. It was part of the necessary extravagance of war—for war is waste, at best."

A pioneer in hiring disabled workers, the plant employed teams of inspectors, all women, and many of them deaf.

It happened partially by design and partially by coincidence. In its Des Moines, Iowa plant, U.S. Rubber Company incorporated the deaf in its workforce with excellent results. When U.S. Rubber opened its Milwaukee Ordnance Plant, the army assigned Colonel Arthur M. Wolff to oversee operations. In civilian life, Wolff had been a board member of the Institution for the Improved Instruction of Deaf Mutes in New York City.

With both the company and army solidly behind the idea, word went out urging deaf women to apply at the Milwaukee plant.

The *Milwaukee Journal* reported:

> On one of the many inspection lines of the United States Rubber Company in the Milwaukee Ordnance Plant on the Port Washington Road are a

dozen or so women. They all smile. Working with lightning speed they are really happy about the chance to work. That inspection line is just about the pride of the plant.

Not one of them can hear and most of them are mute.

Since March they have been on the job at the ordnance plant as a team. Their job is speedy and rather intricate and there must be no mistakes.[78]

Deaf workers are ideal employees, Wolff said, "Noise does not distract them. There is never any idle conversation, and they generally have the steel will to succeed on the job with steady and hard work."

The visit of the newspaper reporter included an amusing incident. Standing before a glass window in an enclosed office overlooking the factory floor, a visitor commented on the attractive appearance of one of the deaf workers. The young woman, seated at a distant inspection line, suddenly blushed while her co-workers grinned.

A company official told the startled visitor the workers can easily lip-read from forty feet away.

The *Journal* article noted a silk American flag adorned the factory ceiling, purchased with contributions from the entire inspection department. The workers were invited to write statements for the visiting reporter. Most expressed heartfelt gratitude for the opportunity of working on a war job.

"We deaf people cannot join the WAACS or the WAVES," wrote Sophie Rubin. "So the next best thing we can do is to be of service in the war plants. I am very proud to work here under our very beautiful American flag."

Another of the workers stated simply: "We all think Colonel Wolff a swell guy."[79]

19
HUNGOVER? QUAFF-AID TO THE RESCUE!

In 2015, workers demolished an abandoned three-story factory at 3456 North Buffum Street in Milwaukee. Built in the early 1900s, when Keefe Street marked Milwaukee's northern city limit, the building originally housed Jager Lumber & Manufacturing's furniture factory. A triangular lot along the Milwaukee Road's busy "Beer Line," the railroad right of way dictated the building's odd shape. According to a 1910 fire insurance map, woodworking machinery originally occupied the first floor and the second floor housed a cabinet shop, with storage on the third floor. A boiler house attached to the east side of the factory housed a steam engine rated at seventy-five horsepower, which powered the machinery and heated the building in winter.

The building housed many tenants in its one hundred years, including a feed and fertilizer dealer, an animal research laboratory, a chemical processor and a fiberglass fabricator, as well as firms manufacturing soap and plastics.

Sixty years ago, this was the birthplace of Quaff-Aid, hailed as a miracle cure for hangovers—until federal agents raided the place.

In the 1950s, this was the home of Amber Laboratories. The company, an affiliate of yeast processor Milbrew, consulted for the brewing industry and researched new markets for brewing byproducts. In spring 1955, Amber introduced Quaff-Aid, a hangover remedy consisting of concentrated brewer's yeast in tablet form.

Brewer's yeast is naturally high in B-complex vitamins and is a long-standing folk remedy for dealing with the morning after a night on the

This building had many occupants in its long life. In the 1950s, it was home to a company marketing a popular hangover cure.

town. Quaff-Aid was heavily advertised in Milwaukee newspapers with the cheerful promise of "No regrets tomorrow for feeling good today."

Milwaukee being Milwaukee, the hangover pills sold like hotcakes.[80]

The company soon introduced a Carry Home Party Pak (five two-tablet packages for ninety-eight cents) and suggested hostesses kick off an evening's festivities by distributing Quaff-Aid to their guests. To sweeten the deal, the party packs included paper napkins.

Sold in local drugstores and corner taverns, Quaff-Aid promised "a wonderful time…every time! You'll be poised, assured, relaxed; have a wonderful sense of lighthearted freedom from worry because you know your fun won't be spoiled!"

With sales more than doubling each month, the company recognized it had a winner on its hands and started planning national distribution. Then the party was over. In October 1956, the federal government swooped in and seized a quarter million hangover pills. The Food and Drug Administration claimed the product was ineffective.

Not so, protested Sheldon Bernstein, Amber's director of research. Bernstein told the *Milwaukee Journal* the B vitamins in Quaff-Aid were necessary for speedy recovery from overindulgence. Letters from consumers praising the product proved the product's efficacy, he added. Doubtless formerly bleary-eyed drunks all over town agreed with Bernstein, but there was no budging the sober forces of justice. Quaff-Aid never returned.[81]

Amber Laboratories recovered quickly from the setback and soon moved out of the building on North Buffum Street. Over the years, Amber expanded into the manufacture of yeast extracts, distilling industrial and beverage alcohol and making animal feed supplements. In 1983, Amber's annual sales topped $10 million, and Universal Foods acquired the company.[82]

The last tenant in the Buffum Street building, a recycling center, closed in 2008, leaving behind asbestos, lead, solvents, waste oil and a great many other flammable and corrosive materials. The Environmental Protection Agency conducted an emergency Superfund cleanup in 2014 just to make the building safe enough to tear down.[83]

Then heavy equipment arrived and leveled the tired old structure. There was no one present to raise a glass to the former home of Quaff-Aid.

20

THE DAY SCHLITZ CLOSED

Few companies soared as high—or fell as fast—as the Jos. Schlitz Brewing Company: "The beer that made Milwaukee famous." It's a story of larger-than-life personalities, dazzling product and marketing innovations and a final, stunning fall from industry leader to historical footnote.

From the early 1900s to the 1950s, the title of largest beer producer in the United States alternated between Schlitz and rival Anheuser-Busch. Then Schlitz fell apart. The reasons are many and complex, but in a sense, the final act played out in a nondescript modern warehouse on North Teutonia Avenue.

Schlitz's roots reach back to 1849, when German immigrant August Krug began making beer in the basement of his restaurant. Krug hired fellow immigrant Joseph Schlitz, then twenty years old, as bookkeeper. In 1856, Krug died, and Schlitz took over management. Two years later, he married Krug's widow and changed the name of the firm to Jos. Schlitz Brewing Company.

Following the Great Chicago Fire of 1871, which destroyed most of that city's breweries, Schlitz opened a distribution center there and began the slow, steady expansion that made the company a national brand.

In 1875, Joseph Schlitz died in a shipwreck while on vacation in Europe. He had steered the company through a time of amazing growth. In 1849, its first year of operation, the company sold 500 barrels. At the time of Joseph Schlitz's death, production had reached 70,491 barrels—an increase of 14,000 percent in twenty-six years.

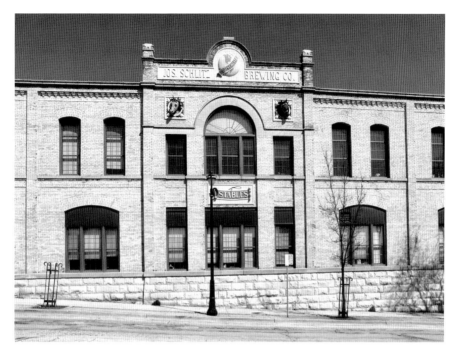

The buildings in the former Schlitz Brewing Company complex are reminders of a onetime powerhouse in brewing.

Control of the company was placed in the hands of four Uihlein brothers, nephews of August Krug. The Uihlein family entirely owned the brewery until 1962 and maintained a controlling interest after the company became publicly traded.

Author Ernest L. Meyer recalled the brewery in its heyday:

> *Every day the brewery wagons, dozens of them, would clatter, laden, past our house in the early morning and return in the late afternoon, with empty barrels. They were drawn by teams of magnificent Percherons whose great shod hooves struck sparks from cobbled street. The harness dazzled the eye with the gleam of sunlight on polished brass. Perched on the very high seat of the van were the driver and his helper, robust fellows in leather aprons and clean peaked caps, and so strong they could lift and roll full barrels of beer with the apparent ease of a child trundling a hoop.*[84]

In 1932, the *Milwaukee Sentinel* profiled Alfred Uihlein, who, at eighty, had just stepped down from the post of Schlitz president. For sixty years, Alfred

had purchased every pound of hops and every bushel of barley that went into making Schlitz. Given a sample of hops, Alfred could tell with a quick glance, sniff and touch, whether it had been grown in California, Oregon, Bavaria or Poland.

When asked the secret of the company's remarkable growth, Uihlein said, "Well, I suppose we had ideas. One of them was that we must make good beer."

The article concluded with these words: "Native shrewdness, the ability to turn events to their own uses, a number of happy accidents, and the smile of the gods upon them, combined to speed the Uihleins' unbroken, amazing rise."[85]

In the 1970s, the gods stopped smiling on Schlitz. During that decade, sales declined by 40 percent, and the brewer fell from the nation's second largest to a tie for fourth place. Between 1973 and 1981, Schlitz, the country's bestselling beer for most of the quarter century following Prohibition, lost six of every ten customers it had. Over the same period, the value of a share of company stock tumbled from sixty-eight dollars to five.[86]

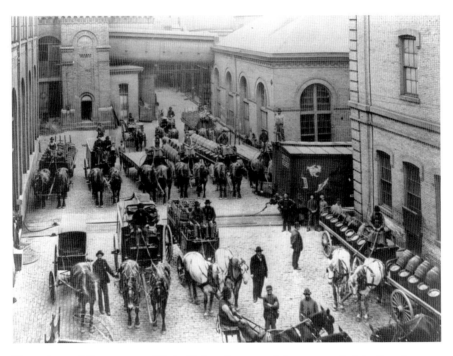

Horse-drawn delivery wagons filled with beer kegs crowd the courtyard of the Joseph Schlitz Brewing Company around 1900. *Courtesy of the Library of Congress.*

What went wrong could fill a book and included an aggressive three-year federal probe into marketing practices. Moreover, the marketing department, which once seemingly could do no wrong, floundered repeatedly in seeking a new direction for its advertising. Attempts at diversifying the company's business turned into expensive fiascos. And Chairman Robert Uihlein, the fourth member of his family to lead the company, died suddenly of acute leukemia, leaving a leadership vacuum.

Most damaging of all were problems with its core product. Seeking to maintain profitability by cutting costs, Schlitz reduced the hops and barley it used. This required the addition of other ingredients to stabilize the beer and keep it looking and tasting good.

In 1976, many Schlitz drinkers hankering for a tall frosty brew were surprised to pour out a glassful of weird, murky slop. Although the beverage was safe, it looked awful. It took time to unravel what had gone wrong. In fact, Schlitz squandered a critical six months denying there was a problem—only to abruptly change course and recall ten million bottles and cans of beer.[87]

What happened? At the time, the U.S. Food and Drug Administration proposed regulations requiring the listing of ingredients on beer labels. Schlitz was using enzyme-enriched silica gel to stabilize its beer. Worried about how consumers might perceive that ingredient, Schlitz replaced it with a product called Chill-garde, which could be filtered out before bottling, avoiding the need to list it on the label.

Apparently, no one at the brewery checked how Chill-garde would react with another ingredient, a foam stabilizer. Mixed together, they triggered formation of protein chains, harmless but becoming more and more visible the longer the beer sat on the shelf.

An attempt to fix the issue created more problems. Instead of switching back to the familiar silica gel enzyme, management decided to keep using Chill-garde and remove the foam stabilizer instead. With its already low barley and hop content, the beer quickly went flat. Tired of surprises, customers fled the brand, never to return.

The downfall of Schlitz was the subject of an article by Jacques Neher of Crain Communications that appeared in the *Milwaukee Journal* in two installments in June 1981 under the blunt title "What Went Wrong."

Neher concluded, "A classic tale of human failing, the Schlitz saga now serves as a reminder for those who might lose sight of the fact that a company—no matter how modern its plants, how endowed its balance sheet, or how lionized by Wall Street analysts—is really no stronger than the human beings who manage it."

In other words, the company should have remembered Alfred Uihlein's secret of success from 1932, "We must make good beer."

When the dust settled in 1981, Schlitz was looking to merge with, well, anyone. But at least its production woes were in the past and the company was still making beer at breweries in Milwaukee; Memphis; Los Angeles; Winston-Salem, North Carolina; Longview, Texas; and Tampa.

The product might have returned to its former standard, but the corporate balance sheet did not. When its union contract came up for renewal, the company took a strong line in negotiations, offering its Milwaukee workers no pay increase at all, even though local employees of Miller and Pabst had just won one-dollar-an-hour increases in their new contracts.

Pouring salt on the wound, Schlitz said it would cut union jobs not directly involving brewing, such as lawn mowing and snow and garbage removal. It also announced plans to close its city distribution center at 6800 North Teutonia Avenue, fire company drivers and outsource deliveries to a Milwaukee beverage distributor. All told, about two hundred jobs would be lost.

The Schlitz city delivery warehouse was the center of a 1981 labor dispute that ultimately saw the closure of the famed brewery.

Lawn mowing and garbage removal were one thing, but local beer delivery had been a traditional function of brewery workers since the days of horses and wagons. For the rank and file at Schlitz, the plan to outsource local distribution was the final straw. On June 1, 1981, more than seven hundred members of Brewery Workers Local 9 walked off their jobs. Two months later, with picket lines still in place, Schlitz announced it would end brewing operations in Milwaukee.[88]

When the news broke, the Associated Press quoted an industry analyst, Donald W. Rice, who correctly predicted the massive plant would never reopen. "As of today, it's just real estate," Rice told the AP.

Schlitz's first brewery was on West Juneau Avenue between Fourth and Fifth Streets. Where it ended, 132 years later, is harder to pin down. But if you had to pick one place, it might be a nondescript modern warehouse that still stands—the former Schlitz city distribution center at 6800 North Teutonia Avenue. Here workers took a stand, and Schlitz began fading from the city it once claimed to have made famous.

21
PARK HAS AN INDUSTRIAL PAST

Rotary Centennial Arboretum, south of Riverside Park, is the newest of the city's chain of Milwaukee River parks. Opened in 2013 at a cost of $8.5 million, it is managed by the Urban Ecology Center. It has nearly four miles of trails, outdoor learning areas for school groups and extensive plantings of native trees, shrubs, wildflowers, grasses and sedges.

Most visitors are unaware the park sits atop a specially trucked-in two-foot-thick layer of clean soil that isolates and safely contains the lead, arsenic and other toxic compounds that saturate the original soil.[89] The contaminates are about all that remains of one of city's largest industrial concerns. Established on the willow-shaded east bank of the Milwaukee River in 1901, National Brake & Electric Company grew rapidly, eventually employing 1,400. Its complex included four main buildings, a large machine shop, a foundry turning out more than one thousand tons of castings a month, an office building and numerous smaller structures.

And then it was over. After just thirty years, the vast factory complex fell silent.

The central figure is Niels Christensen. He was born in Denmark in 1865 to a distinguished family. As a child, he spent most his spare time in the workshops on his father's estate. He attended both day and evening schools studying mathematics and applied mechanics. By twenty-one, he was working for the Danish navy. Coming to America in 1891, he found employment with an engineering firm in Chicago and, three years later, joined the Edward P. Allis Company of Milwaukee.

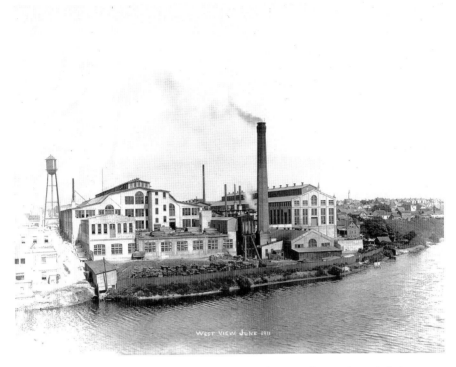

National Brake & Electric Company employed more than one thousand people in its massive plant. *Courtesy of the Milwaukee County Historical Society.*

Witnessing a fatal streetcar accident during his time in Chicago started him thinking of ways to improve the braking systems used on electric railways. In 1892, he designed and patented his first streetcar brake. Tests using streetcars in Detroit and Milwaukee were successful, but it took five more years to find investors, gather initial orders and establish the Christensen Engineering Company.

Oddly, Christensen was not a stockholder in the business bearing his name. Investors Frank G. Bigelow, Samuel W. Watkins and Henry G. Goll provided the financing and owned the works.[90] The company paid Christensen royalties to license his patented designs. He also oversaw day-to-day production.

The Christensen brake quickly became the standard for streetcars around the world. By the early 1900s, orders were pouring into the new factory on the Milwaukee River. Flush with cash and seeing opportunities everywhere, the plant's owners started manufacturing electrical devices. It was a move

strongly opposed by Christensen, who understood the shift in focus would place them in competition with more established firms possessing vastly greater resources. But since he owned no stock, Christensen had no real say in the matter. In 1902, he resigned as general superintendent.

A year later, the business was incorporated under a new name, National Electric Company, and announced plans to double its workforce of six hundred men. In 1905, its principal shareholder, Milwaukee banker Frank G. Bigelow, ran into financial difficulties. At the bankruptcy sale that followed in March 1906, Westinghouse Manufacturing Company purchased Bigelow's controlling interest in the firm, which it renamed National Brake & Electric.

The plant on the bank of the Milwaukee River continued to expand. It tripled in size in the first few years of Westinghouse's ownership. In August 1910, the company announced plans for a four-story-tall, 186- by 247-foot extension to a factory building along with construction of an 86- by 140-foot warehouse. It was the third time in less than a year the company had taken out building permits for additions to its plant.

Westinghouse continued National's streetcar brake business but did so without negotiating a license for Christensen's patents. The inventor responded by licensing his brake patents, all sixty-five of them, to another company. He then filed a patent infringement suit against Westinghouse and turned his attention to new endeavors.

In the meantime, the factory on Milwaukee's East Side was growing rapidly. In its December 29, 1912 edition, the *Milwaukee Sentinel* reported its furnaces consumed 1.25 million gallons of oil a year.

On September 23, 1918, a reporter from the *Milwaukee Journal* described National Brake & Electric as covering fourteen acres, employing one thousand men and women and busy with World War I production. This included four-wheel-drive military trucks, heavy-duty lathes, air compressors and gasoline-powered locomotives.

The *Journal* visited again in 1929 and found workers engaged in making thirty-ton iron castings, so large that the only way to make a mold for them was to dig a pit in the factory floor. Not far away, other workers were performing machine work so precise "it would arouse the admiration of a jeweler."

The reporter's account is vividly descriptive:

> *Thousands passing through the east side of the city have seen the plant from a distance. But few know that it has foundries that are among the largest in the city. There, for the length of a block, sweating toiling men wrestle with*

The site of National Brake and Electric Company as it appears today.

> *massive things, like so many pygmies in a giant's workshop. They labor in a grayish light that seems the more gloomy as spots of brilliant light flash out from pots of molten metal.*[91]

A few months after this story appeared, the company was in the news again. The *Sentinel* announced the end of Christensen's twenty-four-year legal battle in its October 14, 1930 edition. The patent dispute, which involved three separate appearances before the U.S. Supreme Court, ended with an order to National Brake & Electric to pay Niels Christensen, then seventy years old, the sum of $260,000 for infringing his brake patents. Bound together, the case file filled eight thick volumes. The lawsuit had been in the courts so long many of the attorneys and judges involved in its filing had retired and died of old age before it was settled.

The Depression sent Westinghouse's profits into a tailspin. In 1931, the company started moving production from Milwaukee to its factories in Pennsylvania. Westinghouse put the Milwaukee plant on the market but was unable to attract a buyer: one by one the complex of buildings fell silent. On

a bleak February day in 1932, one of the final products made by National Brake & Electric, a locomotive, left the fourteen-acre plant.

"In place of the 1,400 men, there are today six who, as watchmen, rattle around in 14 acres of roofed emptiness," the *Journal* reported. "The vast erecting shops contain a sparrow or two; in the foundry, one of the largest in the city, the overhead crane is doing a last creaking dance pulling out more equipment to be melted up."[92]

When the scrap was gone, the brick and stone industrial buildings began to come down. Demolition of the factory's 150-foot brick chimney was an especially formidable challenge. With walls 4 feet thick at its base the chimney contained two million bricks. Its fall had to be precisely calculated. If it toppled in the wrong direction, it would land on adjoining businesses.

The contractor, Frank Pipkorn, decided to drop it in the direction of the river and proceeded to remove the top thirty feet of the chimney so it would not reach the water. His workers then painstakingly notched out about half the base of the chimney, removing the bricks one by one and wedging heavy wood timbers in their place.

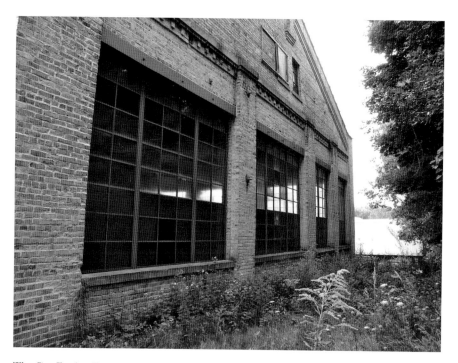

The Gas Engine Test House is the last remaining structure of the once-vast complex. It is now used by the Urban Ecology Center.

The workers, according to an account in the August 30, 1939 *Journal*, then set fire to the timbers, confident the chimney would fall when they burned away. Just then, a rainstorm came along and put out the fire. Confronted by a massive and dangerously unstable chimney—it was largely supported by charred wood—they decided to call it a day and come up with a new plan.

At 9:00 a.m. the following morning, contractor Pipkorn was in his office a few blocks away when he heard a tremendous roar. The chimney had fallen by itself and, Pipkorn was relieved to learn, landed exactly "to the inch" of where he intended, the *Journal* reported.

Its fall placed a final exclamation mark on a corporate history of rapid growth—and of one final shattering collapse.

PART IV

LIFE AND DEATH IN OLD MILWAUKEE

22

MILWAUKEE'S FAVORITE LAKE TRIP

The elegant steamship *Christopher Columbus* operated a summer excursion run between Chicago and Milwaukee from 1894 to 1931. Longer than a football field and licensed to carry 4,000 passengers, the *Columbus* averaged 2,500 people per trip—mostly Chicagoans wishing to sample the delights of Milwaukee during the boat's two-hour layover in the Cream City.

A crew of 170 operated the ship and looked after the passengers. The *Christopher Columbus* was fitted with electric lighting, oak paneling, velvet carpets, etched-glass windows, leather furniture and marble countertops. Skylights illuminated the promenade, which contained several fountains and an aquarium filled with Great Lakes fish. The ship had several shops, restaurants, a full orchestra and a dance floor that accommodated five hundred couples. The *Columbus* also featured several large clubrooms for organizations wishing to hold meetings aboard ship.

Its "whaleback" hull was the ship's most distinctive feature. The only passenger vessel of the roughly forty Great Lakes whalebacks built, the *Columbus* was the brainchild of designer Captain Alexander McDougall. Its cigar-shaped hull had a flat bottom for maximum capacity in shallow rivers and a rounded top to easily shed water. A spoon-shaped bow minimized stress on the broad hull. Six large-diameter watertight turrets atop the sealed hull supported the upper passenger decks. Grand staircases inside the turrets connected the upper decks to the interior of the hull. Not only was the *Columbus* exceptionally stable, but its watertight design

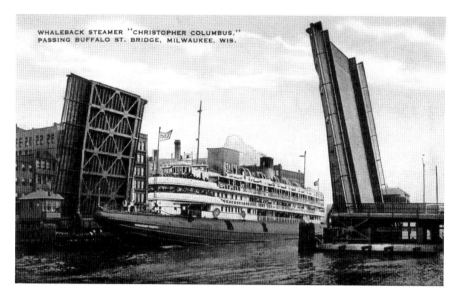

Longer than a football field and licensed to carry four thousand passengers, the excursion steamer *Christopher Columbus* brings another load of tourists to Milwaukee.

meant storm-driven waves could wash completely over its hull without the slightest danger to the ship.

The ship's arrival was a daily summertime event for thirty-seven years. Each afternoon, the big ship glided up the Milwaukee River and docked just south of the Michigan Street bridge. For an extra seventy-five cents, *Columbus* passengers could tour the city in "tallyhos," massive thirty-passenger sightseeing wagons, each pulled by a team of six matched horses. The usual route was from the Milwaukee River dock, east on Wisconsin Avenue to the lake, north on Prospect Avenue to North Avenue, then west around Reservoir Park and south over the Holton Street viaduct.

Many of the ship's excursionists passed up the tour in favor of heading straight to the nearby Schlitz Palm Garden, where they contentedly remained until departure time. For serious drinkers, the party started long before they arrived at Milwaukee. In an interview with the *Milwaukee Journal*, published on March 18, 1933, a former general agent of the steamship line said onboard beer sales accounted for a good portion of the ship's revenue.

The *Columbus* entered service in spring 1893. Built by McDougall to promote his whaleback design and the workmanship of his Superior, Wisconsin shipyard, the *Columbus* carried passengers between downtown Chicago and the World's Fair Columbian Exposition grounds, a distance of

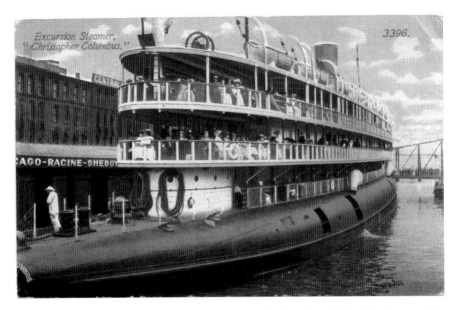

The ladies aboard the *Christopher Columbus* do not need to fret about their white dresses—the Goodrich Line kept its ships spotlessly clean.

six miles. An estimated 1.7 million passengers rode the *Columbus* to the fair that year—10,000 were carried on one trip.[93]

When the Columbian Exposition closed, the ship began operating a daytime excursion round trip from Chicago to Milwaukee in 1894. This brought the *Columbus* into competition with other steamship operators, most notably the Goodrich Transportation Company. Goodrich was a fixture on the local scene, operating a fleet of ships between Milwaukee, Chicago and other Lake Michigan ports since 1856. Before he took up brewing, Captain Frederick Pabst, as part owner of a ship called the *Comet*, joined forces with the Goodrich line.[94]

The *Christopher Columbus* competed for Chicago–Milwaukee passengers with the Goodrich *Virginia*, a luxurious 285-foot twin-propeller express liner. The *Virginia* originally departed Chicago in the morning and returned as a night boat. A round-trip ticket cost $2.50 and included a meal on board. When the *Columbus* began its regular runs, the *Milwaukee Journal* reported in its June 7, 1894 edition how the *Virginia*'s schedule was adjusted to match its rival:

> *The whaleback* Christopher Columbus, *which will arrive next week, will receive a warm welcome. The Goodrich line announced today that*

any rate made by the Columbus *to Milwaukee would be promptly met, and that the* Virginia *will run Sunday excursions—something which the Goodrich people have never before done. It will be a battle to the death, for the Goodrich line is determined to drive the whaleback out of the Milwaukee business, regardless of the cost of the struggle. The* Virginia *is being put in shape to develop all the speed there is in her.*

The rivalry was such that many days the competitors staged an unofficial race. On calm days, the *Columbus* generally won, but in rough weather, the powerful *Virginia* (its hull was designed for year-round service in all conditions) was unbeatable.

The competition got out of hand on the evening of July 18, 1897. The *Christopher Columbus* departed its Michigan Street moorings for its 5:00 p.m. return to Chicago, followed minutes later by the *Virginia*. Almost immediately, the crew of the *Columbus* realized they had left behind twenty-five passengers, mostly children. The *Columbus* stopped and dispatched a tug to collect its tardy passengers. As they were boarding the *Columbus* in mid-river, the *Virginia* approached and, ignoring signals, sideswiped the *Columbus* as it attempted to squeeze past. No injuries occurred, and damage was relatively slight.[95]

A year later, in 1898, the Goodrich line acquired the *Columbus*. The *Virginia* returned to being Milwaukee's "night boat" for Chicago. It was a good outcome for everyone concerned. Goodrich ships were popular and well-maintained. Company regulations, for example, required crews to scrub the white upper decks daily and polish the brass fittings until they shone like gold. Even the fire axes, stowed in glass-fronted cabinets, were buffed and shined until the blades reflected like mirrors. Goodrich ships were freshly painted each year, top to bottom, inside and out. The company was also serious about safety. Weekly fire drills were mandatory, and all company ships were equipped with far more firefighting equipment than the law required.

Year after year, the *Columbus* departed Chicago mid-morning for its round-trip run to Milwaukee. The passengers marched up the gangways in droves, the beer poured freely, the orchestra played on and the money rolled in.

On July 24, 1915, the *Eastland*, a large excursion boat owned by another company, capsized without warning while boarding passengers in the Chicago River. More than eight hundred passengers and crew died. It was the worst loss of life in Great Lakes maritime history.

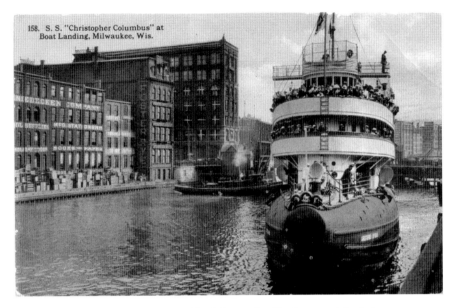

The rounded "whaleback" hull proved both fast and stable. Its watertight design meant waves could wash across the main deck without endangering the ship.

Ominously for the *Columbus*, Chicago officials eyed the unusual whaleback and wondered if it, too, was dangerously top-heavy. In response, and with great public fanfare, Goodrich loaded the ship's upper decks with one million pounds of sandbags, a weight far greater than its maximum passenger load. The company also extended an open invitation to anyone who wished to ride along, and quite a few curiosity seekers took them up on the offer.

In the middle of the Chicago harbor, the sandbags were shifted to the extreme right side of the ship. This caused nothing more than a slight lean to that side. After circling the harbor with its radically off-center load, the Goodrich Line capped the demonstration by having a tugboat tie a line on the right side and try its hardest to pull the ship over. All this effort resulted in a mild twelve-degree list.[96]

It was a triumphant day, and when the *Columbus* departed on its usual run to Milwaukee, it had a capacity crowd aboard.

The Goodrich fleet would see a boom in traffic during World War I. Afterward, improved roads and the rise of trucking companies and private automobiles began to drain the line's freight and passenger business. The *Columbus* continued on the Milwaukee–Chicago run until 1931. The arrival

of the Depression was the final straw, and Goodrich entered bankruptcy. Under new ownership, the *Columbus* was featured at the Century of Progress exhibition in Chicago in 1932–33. It was then stored for a few years before being scrapped in 1936 at Manitowoc.

During its nearly four decades of service, the *Christopher Columbus* carried more passengers than any other vessel on the Great Lakes. In its long service, the ship suffered only one accident that resulted in fatalities. It happened in downtown Milwaukee and remains one of the most bizarre chapters in Great Lakes maritime history.

23

SHIPWRECK IN DOWNTOWN MILWAUKEE

On the last day of June 1917, the excursion steamship *Christopher Columbus* cast off from the Goodrich Transportation dock on the Milwaukee River, just south of the Michigan Street bridge. A familiar visitor, the 362-foot boat made a daily round trip in warm-weather months between Chicago and Milwaukee. Licensed to carry four thousand passengers, this day's load was an unusually light one—a group of two hundred students from the University of Chicago along with about two hundred other passengers.

One of those passengers, university student Emma Taylor, looked down at the dirty river and remarked to her friend, "I should hate to have to bathe in that water." [97]

Minutes later, the *Columbus* was in ruins; sixteen passengers were dead and twenty others injured. And Emma Taylor, with broken ribs, a lacerated scalp and unable to swim, was sinking in the filthy river, her heavy clothing dragging her to the bottom.

Incredibly, the *Columbus*, one of largest and most elegant ships of its time, operated by a safety-minded company and captained by one of the most respected masters on the Great Lakes, had collided with a factory building.

The trip started routinely. As always, a tugboat pulled the departing *Columbus* downstream stern-first with a second tug tied to the big ship's bow. As the collection of boats slowly passed the waterfront factories of the Third Ward, the leading tug turned sharply toward the confluence of the Menomonee River, pulling the *Columbus*'s stern along with it, kicking off an

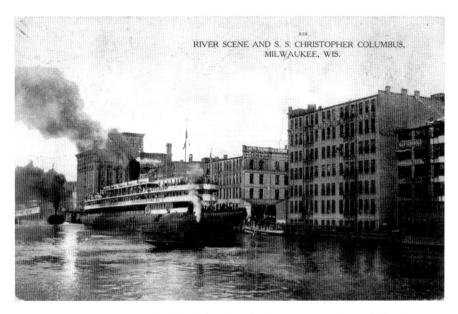

Tugboats stand by fore and aft as the *Christopher Columbus* prepares to depart Milwaukee.

intricate nautical ballet that would see the *Columbus* pivot in midstream until its bow pointed east toward the harbor entrance.

The *Columbus*, longer than a football field, required precise handling in the narrow river, but the maneuver was a well-practiced routine for the three boat crews involved.

On this day, however, they were unaware a rainstorm to the west had sent an unusually strong current surging down the Menomonee River. As the tug nosed into the confluence, it abruptly slowed. The bow of the *Columbus* continued swinging, sweeping across a dock and toward one-hundred-foot-tall steel legs supporting a factory water tank at the foot of Chicago Street.

Aboard the *Columbus*, Captain Charles Moody immediately ordered his ship's engines to reverse at full speed. It was too late.[98]

"When I saw the ship stick its nose into the underpinnings of the water tank, I yelled to the people to get back," Moody said. "But they were too interested, it seemed, in waving to those on shore to heed my warning."[99]

The tremendous momentum of the huge ship snapped two of the tank's steel legs like dry twigs. As the structure toppled over, the tank itself went over the boat, drenching the passengers and landing in the river, clear of the vessel. Its frame of heavy steel beams fell across the forward passenger decks,

smashing Moody's quarters, demolishing the wheelhouse and crushing one of the ship's interior restaurants. Although trapped in the wreckage and with both legs injured, Captain Moody was able to pull himself free.

In an article published on July 2, 1917, two days after the accident, Moody told the *Milwaukee Sentinel*:

> *As the tank rocked back and forth, then crumpled up and crashed upon the bow of the boat, I jumped to the starboard entrance to the pilot house, and Jim Brodie, the wheelman, leaped to the port entrance. As soon as the crash was over, I looked at the spot where Brodie had been standing, but saw nothing but a huge hole. My first thought was: "Jim's dead." I crawled forward of the pilothouse and there was Jim, holding his head in his hands.*
>
> *"Hello, Cap, I thought you were a goner sure," said Brodie, as he caught hold of me. "We had better get busy, Cap. A lot of people have been killed." I ordered the forward workboat lowered, and they began picking the people out of the water.*

Emma Taylor, the college student, floundered briefly to the surface. As she sank a second time, she recalled her brother trying to teach her to swim in her younger days. She had been a lazy student, she told reporters, and

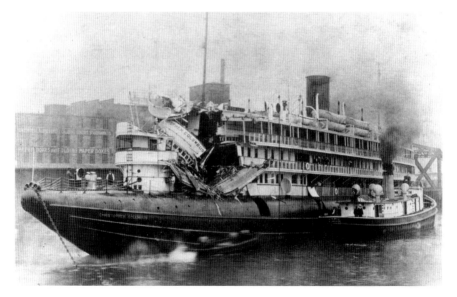

The mangled wreckage of the *Christopher Columbus* shortly after the bizarre accident that killed sixteen people and injured twenty. *Courtesy viewsofthepast.com.*

would just float there as he explained the process. Now, deep under water, she found herself thinking, "'I must swim. I must swim,' and I did. It was the first time in my life."

Taylor reached the surface a second time and, fighting her way through floating wreckage, swam to a life ring.

"My nerve almost failed me, though, when I saw a man, his face streaming with blood, floating about, apparently dead," she told the *Milwaukee Journal*.

By now the tugs had regained control of the *Columbus* and pushed the big ship to the river's edge, where it tied up to the Canadian Transportation dock while the work of rescuing the victims continued.

Frank Woods was working behind the soda counter of the *Columbus*. Feeling the impact of the falling water tower, Woods rushed to the deck and starting throwing life preservers to the passengers in the water. Then, working his way forward, he crawled through a hole in the mangled wreckage and began dragging injured and dead passengers from the crumbled bow area and laying them one by one on the restaurant carpet.

Six physicians, urgently summoned to the *Columbus*, tended to the injured until they could be transported to a hospital, where dozens more volunteer physicians were waiting to provide further treatment.

The *Columbus*, the largest excursion ship in the world at the time, was a sad sight. A reporter described broken glass, chairs, benches and tables, blood-soaked canvas and lifebelts in heaped confusion. The red carpets of the forward dining room were water-soaked from the falling tank, covered with shattered glass, broken timbers and food items dropped by terrified passengers.

The ship was out of service for the rest of the year. Rebuilt, it returned for the 1918 summer season and continued to operate between Milwaukee and Chicago until 1931. Captain Moody, whose career on the lakes started at age fourteen and lasted sixty-six years, including twenty-six years as master of the *Columbus*, died in 1944 at the age of ninety-three. He was fond of boasting that he hauled more passengers in his career than any other captain in the world.

Of that dark day in 1917, he said, "There was no panic. Only silence prevailed. I would have felt better if somebody had yelled."[100]

24
"MARRIAGES SOLEMNIZED HERE"

In the 1890s, couples flocked to Milwaukee to take advantage of laws allowing immediate weddings—no license, no waiting period and hardly any questions asked.

On any given day, the excursion steamer *Christopher Columbus* was sure to have a few eager couples boarding at Chicago for the trip to Milwaukee. When those couples sat down for a meal, they would find advertisements on the ship's menu from Milwaukee justices of the peace offering special deals for the marriage minded.

One minister frequently rode the *Columbus* to Chicago just so he would be in position to talk up his brand of instant marriage on the return trip to Milwaukee. A local justice of the peace had a large sign on his downtown Milwaukee office, "Marriages Solemnized Here."

So notorious was the city that the phrase "Milwaukee marriage" became a handy way to spice up newspaper stories of an especially scandalous marriage, divorce or spousal abandonment—never mind if the couple in question had actually been married somewhere else.

Thanks to a prime location at Fifth and Wisconsin not far from the Goodrich dock at Michigan Avenue, many of the marriages were performed by the Reverend Wesley A. Hunsberger of the Grand Avenue Methodist Episcopal Church.

One Sunday in 1895, a reporter dropped in to watch the action:

While doubtless there are many ministers who perform as many marriages as the Rev. Mr. Hunsberger, it is not probable any other minister is called upon to go through so many in so short a space of time. The boats only remain in Milwaukee two hours, and of that time one hour is consumed in getting to and from the wharf.

The Rev. Mr. Hunsberger understands this. And it is only necessary to see him work to become convinced he is the most expert of his kind on earth. While he jollied the timid victims of marital fever he worked swiftly at the registration blanks, filling in the names, ages, occupations, birth-places and so on of fathers, mothers, and everybody concerned and not concerned.[101]

With the form filled in, he swiftly conducted the service, handed over the marriage license and pocketed his "donation" (usually five dollars, which was about four or five days' wages for an unskilled worker). As the newlyweds departed, the reverend's wife ushered in the next couple and immediately shepherded two more couples into a side room to wait their turn.

Five couples had been united in less than an hour, the reporter noted, and two had previously joined, making it seven that day.

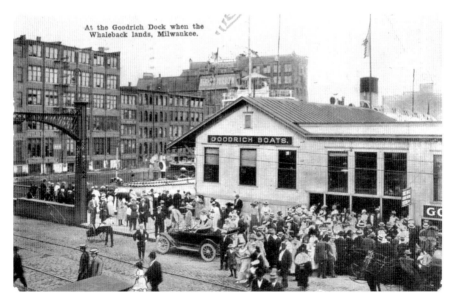

The Goodrich Transportation dock is jammed with disembarking passengers. In the 1890s, a good number of them would have been in search of quick marriage.

"I married 87 couples in August," Hunsberger told the reporter. "In July, I married 81 and in June 62. I average nine couples every Sunday. The highwater mark was reached on the Fourth of July when I married 12."[102]

In three years at the church, Hunsberger joined 2,079 couples in wedlock, cementing his reputation as the "marrying parson" and making him a target for critics.

When the *Milwaukee Journal* visited in 1895, Hunsberger told the reporter his predecessor, the Reverend Dr. Sabin Halsey, left him with the following advice: "Marry those who come to you whom can marry legitimately, put the fees they give you in your pocket, thank God for them, go quietly on about your business, and let the other fellows, who never get any weddings, do the howling."[103]

The marriage business dried up in 1899 when the Wisconsin legislature passed a bill requiring every couple to obtain a license issued by the county clerk at least five days before a wedding ceremony. The *Milwaukee Journal* reported the bill's passage:

> *No longer will the wandering couple be welcomed to our gates and hastily joined in the sacred bonds of wedlock while they wait with a blessing and a guarantee thrown in, all for a paltry fee. No more will the rich and the poor, the high and the lowly, the beautiful and the homely, the famous and the unknown, the sober and the intoxicated, the serious and the gay, all kinds and conditions of men and women flock promiscuously on train, wheel, afoot, in carriage or on the excursion boat, to this city and return forthwith one where there were two before. The fame of Milwaukee has passed. She has nothing now to rely upon for undying notoriety but beer.*[104]

25
THE LOST BUSINESS DISTRICT

The six blocks of Martin Luther King Drive between Burleigh Street and Keefe Avenue are like many on Milwaukee's north side. There are churches and liquor stores. There is a public school and a private choice program school. There are vacant buildings and vacant lots.

There is nothing to show this street's history extends back hundreds of years to Wisconsin's first inhabitants.

The street follows the route of an ancient Indian trail connecting Chicago and Green Bay. One of two historic trails to Green Bay (the other followed the shore of Lake Michigan), the trail became a road, Green Bay Avenue, a name it kept until 1985, when it was renamed to honor the civil rights leader. (The avenue resumes its original name north of Capitol Drive.)

As Europeans moved in, the Indian trail began to see more traffic: fur traders, soldiers, settlers and, starting in the 1820s, mail carriers. The crude trail, with thick foliage and frequent rock outcroppings, made it nearly impossible to use horses. Travelers between Wisconsin's far-flung settlements trudged on foot for days through dense maple forest, tamarack swamps and small prairies.

Historian William George Bruce quotes an early Green Bay resident: "Once a month a mail arrived, carried on the back of a man who had gone to Chicago, where he would find the mail from the East, destined for this place. He returned as he had gone, on foot, via Milwaukee. This day and generation can know little of the excitement that overwhelmed us when the mail was expected."[105]

On a street that was once an Indian trail, fine buildings are reminders of a once prosperous business district.

The letter carriers on the trail carried parched corn for food, supplemented by what wild game they could kill along the way. Still, Bruce noted, "There were many times mail carriers traveled for days on the verge of starvation; just as common a hardship was freezing the feet, in some instances the men losing their toes as a result."[106]

Attracted by rich soil, farms began to sprout up along the old trail. One of the early settlers, William Bogk, purchased the high ground near present-day King Drive and Burleigh Street and opened a picnic grounds. The village growing around him became known as Williamsburg. By 1850, it was an independent community of 3,500. Williamsburg had a blacksmith shop, a general store and a windmill.

In 1867, John Grootemaat Sr. built a large windmill to grind flour at the northwest corner of King Drive and Ring Street. Identical to those found in Holland, the three-story-tall building had four arms, each thirty-four feet in length. It was a one-of-a-kind building for this area. In 1885, a fire broke out in the general store. Hampered by an inadequate water supply, villagers could not stop the fire from spreading to the mill sixty feet away. It burned to the ground.

The fire settled an important question for the community. It needed the services a large city could provide. In 1891, Williamsburg officially became part of Milwaukee.

Life and Death in Old Milwaukee

In 1911, when Keefe Avenue marked the northern city limits, the six-block stretch of Green Bay Avenue—the business district of old Williamsburg—was both one of Milwaukee's shortest streets and, with two hundred retail establishments, one of its busiest shopping destinations.[107]

The *Milwaukee Sentinel*'s September 21, 1912 issue reported:

> *Green Bay Avenue has become a part of the city well known for enterprise and progress, it has maintained a certain individuality, which it retains to this day. The old conservative German element, which has maintained Milwaukee's reputation of the "German Athens of America" is yet strong. German thrift and methods still prevail. Residents say one can buy on Green Bay Avenue cheaper than in any other section of the city.*

An article in the *Sentinel*'s December 4, 1923 issue described the street's holiday decorations: "Fir and cedar trees have been placed along the curbing and brilliant arcs span the street. Merchants along Green Bay avenue have decorated their windows and some remarkable displays greet the eye. Santa Claus makes his appearance on the streets each night and presents the children with gifts."

Its reputation as a shopping destination lasted many years. John R. Prindle of Verona, Wisconsin, shared his childhood memories of Green Bay Avenue in a letter published in the January 9, 1992 *Sentinel*:

> *There was a bank, a florist shop, at least two dentists, a shoe store, a Woolworth's, at least two Woolworth copies, a wonderful bakery, a famous butcher shop, a hamburger joint, a furniture store, a Walgreen and a competing drug store, two or three taverns, two sporting goods shops, three bowling alleys, and Solly's, a wonderful place where a hamburger became not a fast-food gimmick but a memorable butter-soaked delight.*

In 1962, a newspaper advertisement listed forty-seven merchants on the avenue between Auer and Keefe.

Five years later, on the night of July 30, 1967, violence and racial unrest ripped through cities across the United States, including Milwaukee. The rioting lasted until the early morning hours of July 31, with multiple shootings and burned buildings, much of it centered on what was then upper North Third Street.

When it was over, four people were dead, one hundred people had been injured and 1,740 arrests had been made. And although it took years to

A former F.W. Woolworth store on North Martin Luther King Drive recalls the street's years as a major shopping district.

become apparent, there was one more casualty—the riots put an end to Green Bay Avenue as a shopping destination.

The street went into a tailspin after the rioting, Elliot Finch of the Green Bay Avenue Business Association told a newspaper reporter in 1984. With shoppers staying away, many of its businesses either closed or moved to the suburbs.

Still, Finch told the newspaper, "Our progress is coming because we now have businesses that are well established, that aren't going to run from the neighborhood."

"We are handling all of our problems," he said. "We've hit the bottom and now we are coming back up."[108]

Three decades later, the handful of operating businesses mentioned in that 1984 article themselves have closed or moved—even the name of the avenue changed. But the history remains, and it runs very deep on the northern end of Martin Luther King Drive, where Indians walked a forested path long before there was a Wisconsin.

26
TRAGEDY AT THE ORPHANAGE

Few traces remain of St. Aemilian Orphan Asylum in St. Francis. There is nothing to remind a visitor of the mysterious poisonings of four young boys in 1929 or, one year later, the unexplained fire that gutted the institution.

The St. Aemilian Orphanage for boys was founded in 1849. Originally housed in a small dwelling just north of St. John's Cathedral on Jackson Street, the facility relocated to the St. Francis Seminary grounds south of the city in 1854, where it was operated by the Sisters of St. Francis of Assisi, a Catholic religious order. In 1896, the orphanage was heavily damaged in a fire and subsequently rebuilt.

According to a history produced by the Archdiocese of Milwaukee, "Boys living at the orphanage were given an education, participated in several outdoor recreational activities and were expected to help with basic domestic chores such as cleaning dishes and polishing the floors. Donations from private persons, societies and annual collections from German parishes helped fund the orphanage."[109]

Tragedy visited one morning in February 1929 when 4 young residents were sorting cabbages in the cellar of the massive building. When this chore was completed, they joined 166 other orphans for a lunch of beans and sauerkraut. That morning, though, they had found something more appetizing—a small paper bag containing what seemed to be sweet-tasting cookie crumbs.

By the afternoon of the following day, reported the *Milwaukee Sentinel*, two of the boys, Philip Giganti (thirteen) and Joseph Djeska (twelve) were dead. The other two, Frank Novakovich (thirteen) and his brother Paul (twelve) were desperately ill. The orphanage's staff physician, along with another doctor called in to assist, had no difficulty establishing the cause—arsenic poisoning.

Arsenic compounds are tasteless and in granular form can resemble sugar or flour. It is a naturally occurring metal with many uses. Dyes and paint pigments have been made from arsenic. It was also once used in flypapers and products to eliminate rats and mice. The poison kills by interfering with production of enzymes within cells. Initial symptoms include vomiting and extreme abdominal pain. If the dose is a high one, within a few hours, the sufferer's blood pressure drops and death from multiple organ failure results.

For the coroner's and sheriff's department officers investigating the orphanage tragedy, the cause of the deaths and illnesses was clear almost from the start: the boys found and consumed arsenic-based poison. But who put it there?

Sister Superior Mary Amabilis looked into the matter. A few months previously, she learned, orphanage staff dealt with a rat problem in the basement but had used a phosphorous-based poison. In fact, all poisons on

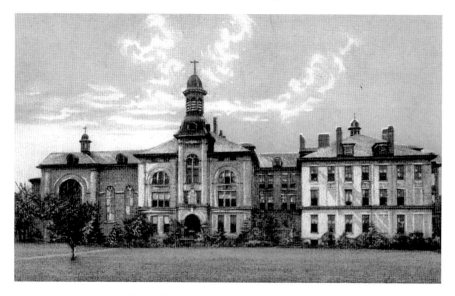

A postcard image shows St. Amilianus Orphan Asylum in St. Francis, Wisconsin. In 1929, two young orphans died here in a mysterious poisoning.

the property were found to be under lock and key and in forms safe for humans. Arsenic, Sister Amabilis told the *Sentinel*, was simply not on the premises in any form—and never had been.

In the meantime, authorities searching the basement were strangely unable to find the paper bag, which one of the surviving boys said had been wadded up and tossed aside before they went upstairs for lunch. At the bottom of a vegetable bin, however, investigators discovered a few brown grains of arsenic. Since the boys said the substance was in the form of loose crumbs, authorities reasoned the poison could not have been there long, for the dampness of the cellar would have soon turned the granules into a solid clump.

In the end, investigators found no cause to suspect anyone on the staff of criminal intent, nor did they uncover any evidence of improper handling of dangerous substances. Officially, the boys' deaths were ruled accidental. The other two poisoning victims, brothers Frank and Paul Novakovich, soon recovered.

Three days after their fatal visit to the basement, joint funeral services were held at the orphanage chapel for Philip and Joseph. In his sermon before more than one hundred orphans, the asylum's workers and relatives of the two victims, Father Joseph F. Kroha, the orphanage superintendent, described his sorrow at the boys' demise. The priest then launched into an angry denunciation of local newspapers, which had, he said, given the fatal poisoning of two children "undue publicity"—publicity that was, he added, "salacious, scurrilous, and libelous filth thrown at a Catholic institution." Reverend Kroha also suggested boys as old as these should have known better than to eat an unknown substance.[110]

With that, Philip Giganti and Joseph Djeska were laid to rest in a grassy field in the nearby cemetery of St. Francis Seminary. Their graves are not marked.

Just over a year after the poisoning, a final disaster befell the orphanage. At 1:00 a.m. on May 22, 1930, passing motorists spotted flames coming from the four-story brick and wood frame building. Luckily, one of them was familiar with the layout of the building and quickly roused staff members.[111]

Motorists and a motorcycle policeman joined the 26 nuns in residence in awakening and guiding 183 boys ranging in age from four to fifteen down fire escapes to safety. The evacuation was calm and efficient. Not a single resident was injured. Completely engulfed within a half hour, the massive structure was a total loss. As with the poisoning, the cause of the fire was never established.

A stone pillar marks the location of a long-gone driveway. It is a silent reminder of the former orphanage, which was burned down in 1930.

After the fire, the orphanage relocated to Sixtieth and Lloyd Streets in Milwaukee. In the 1950s, it moved again, to 8901 West Capitol Drive. St. Aemilian stopped housing orphans in 1963 as the need dwindled but—now known as Saint A—continues as a major provider of social services.

At the seminary grounds in St. Francis, all that remains are a pair of stone entry pillars next to the entry drive, a broken lamppost in the adjoining woods and unanswered questions.

27
THE HATPIN ORDINANCE

In 1913, the Milwaukee common council passed an ordinance placing limits on the length of hatpin allowed within city limits. Specifically prohibited were an "Exposed point protruding more than one-half inch beyond the crown of the hat (unless)…the exposed point is covered with a guard."[112] If a lady's hatpin exceeded the legal limit, she was subject to arrest and might be fined a dollar. (The equivalent of twenty-three dollars today.)

Newspapers had a great deal of fun with this, wondering sarcastically what the city was coming to when women who wear pins protruding five-eighths of an inch from the crown of their hats were not apprehended. In its May 12, 1913 edition, the *Milwaukee Sentinel* asked, "Will the police stretch a tent over Milwaukee and arrest every woman therein who wear a hat, charging violation of an ordinance of the common council known as the hatpin ordinance?" Its headline warned, "Police may swoop down on fair Milwaukee at any time."

In addition to keeping their hats firmly in place, women of the time regarded the pins as useful in self-defense.

On January 9, 1913, the *Milwaukee Journal* reported the plight of Henry Pritkin. The man was a passenger on a very crowded streetcar, and each time the car lurched he bumped into a seated woman, described by the *Journal* as "beautifully dressed and looking petite and dainty."

She didn't like being jostled. Neither did Mr. Pritkin, but he couldn't do anything about it. Suddenly, the newspaper said, after Pritkin had fallen

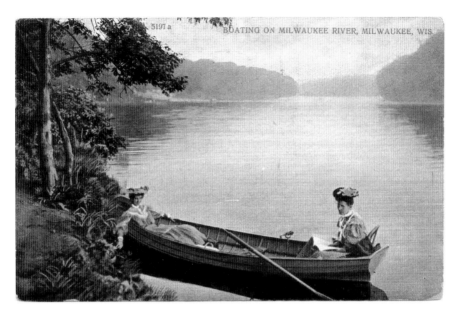

Where there are hats like these, pins are needed. In 1913, the common council decided something had to be done about the menace of hatpins.

against her yet again, she rose, unsheathed her hatpin and exclaimed, "If you do that again I'll run this through you!"

Pritkin protested that he was not purposely bumping into her. "That makes no difference," she said. "You stay here"—indicating a spot—"or you'll get this pin in you."

At this point, the *Journal* reported, the woman became aware she had the undivided attention of all the streetcar's passengers. Blushing bright red, she got out at the next stop.

Certainly, the pins could be useful in time of need.

In 1909, a twenty-five-year-old machinist named Fred Hoelzer attempted "unwelcome advances" on Alice Bohan, who responded by deploying her hatpin and chasing her would-be assailant several blocks. He was arrested, found guilty (of the crime of "mashing") and sentenced to six months in jail.[113]

Although the city's hatpin law was widely mocked at the time and is still occasionally cited in lists of weird local ordinances, one expert put the matter in perspective. In a *Milwaukee Journal* interview published on January 20, 1929, hat manufacturer Henry P. Neubert said, "It was a necessary ordinance. Why, some of those hatpins were 12 inches long. People were

injured by them; some had an eye put out when a lady suddenly turned her head."

Hatpins have been out of fashion for a century, but if they make a return, the women of Milwaukee may wear them without worry. In 1982, the common council abolished several obsolete ordinances, this one included.

28
THE TUBERCULOSIS PARK

Tuberculosis isn't particularly feared today, but in the nineteenth century it caused more deaths than any other disease. If you were living a century ago, you probably were exposed to the tuberculosis bacillus. If your exposure happened to develop into active tuberculosis—consumption, as it was then called—you had a 20 percent chance of surviving the illness. It was a terrifying and deadly epidemic.

In the early 1900s, a flood of desperately sick people stressed city healthcare systems to the breaking point. If you became ill in Milwaukee around 1911, you might have been hospitalized in a temporary sanitarium located in Kern Park in Milwaukee's Riverwest neighborhood.

The park was then a fairly new addition to the city. The thirty-acre property was formerly the summer residence of the Kern family:

> *The Kern tract is a beautiful place on the west bank of the Milwaukee river. It is already laid out in park shape, is in an excellent state of preservation, and will, undoubtedly, prove one of the most popular picnic resorts in the city. The Park Commissioners favor having the city secure all the land it possibly can along the Milwaukee river, as it will aid in eventually securing the long-desired River Drive and preserve this beautiful stream to the public.*[114]

In 1910, before the city had a chance to do much with its new park, the health commission asked the park board for permission to house tuberculosis

Life and Death in Old Milwaukee

Kern Park, the summer retreat of a wealthy family, was once a tuberculosis hospital. During the winter of 1911, patients were housed in tents.

patients on the former Kern property. Although unoccupied, the Kern's twenty-room mansion was thought to be suitable for use as a hospital.

The Social Workers' Tuberculosis Sanitarium opened in Kern Park in October 1911 "for incipient and convalescent cases." Patients paid a fee ranging from five to ten dollars per week, although free care was provided to those unable to pay.

In 1911, the annual report of the city park commissioners had this to say about Kern Park:

> *The only improvement made in this park was the laying of 943 feet of four-inch water main from Humboldt and Keefe avenues to the vicinity of the residence, this pipeline being planned as part of the future water system of this park. Free use of the residence was granted temporarily by the Park Board to the Social Workers' Tuberculosis Sanitarium as a convalescent hospital, the building being used by the attendants, the patients sleeping in tents erected about the park. About 25 convalescents were cared for during the winter.*[115]

Keeping patients in tents seems to imply a certain disregard for their comfort, but good nutrition, lots of rest and plenty of fresh air was considered the best treatment for tuberculosis. The general idea

was to give patients an environment in which they had a fighting chance to build up their immune systems.

On July 14, 1912, the *Milwaukee Sentinel* noted that wastewater from the former residence drained directly into the river, and sanitarium operators had been ordered to put an end to the practice. It is possible the sanitarium closed rather than undertake costly plumbing work on what was, after all, a temporary operation. The sanitarium was gone by 1914, when Milwaukee's main tuberculosis hospital opened at the County Grounds in Wauwatosa.

PART V
STREETCAR DAYS

29
THE DEPOT IN LAKE PARK

A century ago, the Milwaukee Electric Railway & Light Company (TMER&L) operated one of the largest, most innovative and best-run transit systems in the nation. The single company supplied the city with both electric power and mass transit until 1938.

At its peak in the early 1900s, the TMER&L operated hundreds of streetcars on 191 miles of track. Streetcars ran on most major thoroughfares in the city. Long-distance electric interurban lines stretched from Milwaukee south to Kenosha, north to Sheboygan and west to Burlington, Waukesha, East Troy and Watertown.

The TMER&L formed in 1896 as a consolidation of many small streetcar, horsecar and steam railway companies into a single, giant system. One of those early operations, the Milwaukee Street Railway Company, built an elegant trolley depot in Lake Park.

Lake Park was one of three Milwaukee parks designed in the 1890s by Frederick Law Olmsted's landscape architecture firm (the other two parks are Riverside and Washington). Of the three, Lake Park became the finest.

The park, with its winding paths and magnificent views of Lake Michigan, was immediately popular. And in the days when automobiles were rare and horse-drawn carriages were for the wealthy, streetcars gave working-class Milwaukeeans easy and affordable access to the new park.

The trolleys reached Lake Park on a double set of tracks on Locust Street served by two major streetcar lines. Trolleys operating up and down Downer Avenue turned onto Locust for a quick side trip to the park. Farther west,

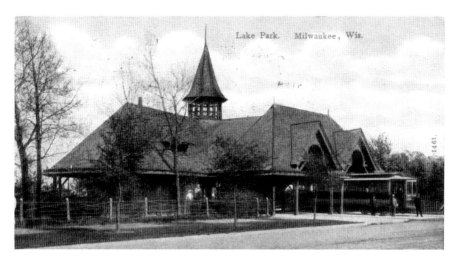

Milwaukee's extensive nineteenth-century streetcar network included this elegant wooden depot in Lake Park.

trolleys on Center Street swung north on Humboldt Boulevard and then east onto Locust for the run to the park.

Most transit systems, then as now, would have been content to install a modest shelter with a bench or two at the end of the line. Instead, in 1894, the Milwaukee Street Railway built an elaborate wooden structure with a tall, peaked roof in the Swiss chalet style. Designed by architect Holland Russell and built at a cost of $7,000, the center section sheltered streetcars boarding and discharging passengers on side-by-side tracks.[116] One wing of the building had a restroom for railway employees; the other end had public bathrooms.

When it opened in the mid-1890s, the Lake Park trolley station was the only noteworthy building in Lake Park. An 1897 newspaper article called the station "handsome and convenient" and admired the way its tower rose above the park's treetops.[117]

As an added attraction, the railway also sponsored a summer concert series in the park.

Year after year, the bands played and trolleys rumbled down Locust Street to the lake. But times were changing. The last new streetcar route, the Center Street line, opened in 1909. After that, the streetcar system slowly declined as buses replacing trolleys and private automobiles became common.

Between 1927 and 1937, Milwaukee tore up 26 miles of track, but the system still had 15 routes, 105 miles of track and 586 streetcars. In the

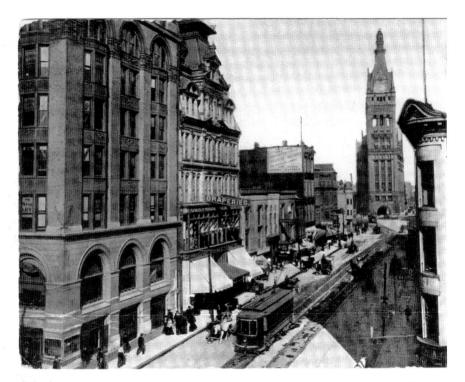

A southbound streetcar mingles with horse-drawn vehicles on Water Street. City Hall is in the distance.

same period, the number of buses increased from 74 to 176. Officials acknowledged the decline but said trolleys would always be a part of the city's transit network.

"The time never will come, in my opinion, when Milwaukee will have no streetcars," said Roy Pinkley, the Electric Company's vice president of transportation in a 1937 interview. "Streetcars are the backbone of the transit system in Milwaukee just as they are in most other large cities. They are the most efficient vehicles for handling mass transportation. No, I don't see the end of them in Milwaukee."[118]

The end was already at hand for the Lake Park Depot. In 1931, buses replaced trolleys on Downer. In 1937, the same year Pinkley gave his optimistic outlook, buses replaced trolleys on the eastern end of the Center Street line.

Buses served the Lake Park Depot until its demolition in 1957. The only reminder of the station site is a paved loop at the east end of Locust Street, used as a bus turnaround.

30

THRILLS ON THE WELLS STREET VIADUCT

For sixty years, the Wells Street viaduct was a Milwaukee landmark and the single greatest engineering achievement of the city's once vast streetcar and interurban empire.

As a thrill ride, albeit an unintentional one, the viaduct had few equals—especially when high winds buffeted the cars. Even veteran riders felt apprehensive as their streetcars rattled and swayed across the rickety-looking 2,085-foot-long bridge, 90 feet above the Menomonee River valley.

The Milwaukee & Wauwatosa Motor Railway Company was formed in the 1890s to build and operate a three-mile line between the intersection of North Thirty-Sixth and West Wells Streets and West Main Street in Wauwatosa, along with a two-mile branch into West Allis. The Motor Railway awarded a contract in 1892 to construct the viaduct across the wide Menomonee valley.

Although 1.3 million pounds of steel and a half million pounds of timber went into its construction, many Milwaukeeans thought the bridge looked ridiculously flimsy. In fact, its Victorian-era designer, Gustave Steinhagen, relied on excellent engineering rather than overwhelming mass. His bridge may have looked insubstantial, but it was amply strong enough to accommodate even very heavy four-car electric interurban trains.

Built wide enough for two railroad tracks, the bridge opened with a single track and a one-lane toll road for pedestrians and wagons.[119] The bridge was soon double tracked, and the Motor Railway became part of the Milwaukee Street Railway Company In 1896, the Street Railway and the several other

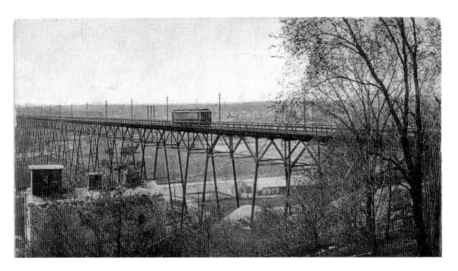

A streetcar crosses the 2,085-foot-long Wells Street viaduct. Built in 1892, the viaduct remained in use until the end of trolley service in 1958.

privately owned lines merged to form the Milwaukee Electric Railway & Light Company.

Although its owners changed, the giant bridge was always kept in excellent repair. In 1927, the structure was extensively rebuilt. Heavy plate girder sections replaced the original sixty-foot-long truss spans. Supporting piers were also reinforced. The work resulted in state regulators approving an increase in the viaduct's speed limit from fifteen to twenty-five miles per hour.

In 1938, Wisconsin Electric Power Company took over operation of what was simply known as the Electric Company, which, in turn, operated streetcars under a subsidiary called, logically, the Transport Company

Thanks to careful maintenance and cautious operation (for a time, signs at both ends of the bridge sternly reminded motormen they were forbidden to cross the valley in less than two minutes), there was never an accident on the viaduct, not even a minor derailment.

Certainly there were plenty of odd occurrences. The viaduct seemed to have an almost hypnotic appeal for drunken drivers. On several occasions, inebriated motorists attempted to drive across the viaduct. Generally, these adventures ended quickly, and their broken vehicles had to be towed away before streetcar service could resume. On at least two occasions, intrepid—and almost certainly stewed-to-the-gills—drivers made it all the way across, their cars bouncing along from one tie to the next high above

Streetcar Days

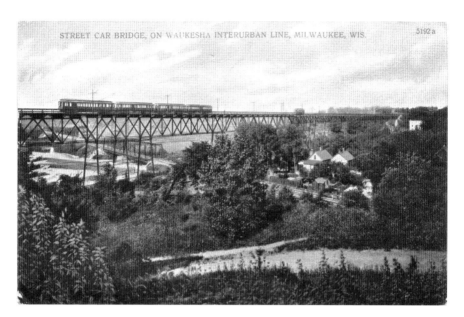

A heavy four-car electric interurban train rolls across the Wells Street viaduct in the early 1900s.

the valley, leaving a trail of shredded tire pieces for railroad workers to find the next morning.

On the night of June 7, 1946, a streetcar motorman spotted a fire in the thirteen-acre Hilty-Foster Lumber Company yard located under the viaduct. He notified his dispatcher, who called the fire department.

The fire, possibly caused by an explosion of stored benzene, was already out of control when the first firefighters arrived, and the blaze quickly grew into a five-alarm inferno, destroying four million board feet of lumber, a box shop, a planing mill, two warehouses, four lumber sheds and eighteen boxcars. Twenty-one fire engine companies and eight ladder trucks—more than half the fire apparatuses in the city—fought the blaze.[120]

Surrounded and at times almost hidden by swirling flames, the viaduct's wooden deck soon ignited and, after burning for hours, collapsed into the valley below. The superheated steel supports warped and buckled as streams of water inundated the burning bridge. Service was suspended for five days while an army of workers from the Transport Company's Way and Structures Department repaired the damage.

The Transport Company completed the change to buses in late 1957, but streetcars continued to serve the Wells Street line into early 1958. It

was a temporary reprieve caused by uncertainty over the continued control of the viaduct. The wording of the original property easements clearly specified the viaduct was for streetcar use. Realizing the legal justification for the viaduct's existence ended the instant the last streetcar rumbled across, the company kept the Wells line going a few additional months while it pondered its options.

The Menomonee valley was a major bottleneck for east–west traffic in the years before the freeway system. Running transit buses over a rebuilt viaduct seemed an appealing option, but nothing came of it.

Finally, on March 2, 1958, the Wells cars made their final runs. The viaduct remained in place for a few years while the city considered a plan to covert it into a vehicular bridge for a proposed east–west highway. The completion of the interstate ended this idea, and bridge was dismantled in 1961–62.

31
A SOMETIMES STRANGE HISTORY

Milwaukee has many transit firsts. It was the first large city to merge independent trolley companies into a single transit system. It pioneered the use of weekly ride passes. And it was first to have a streetcar sink.

It was fifteen degrees below zero on the morning of February 4, 1895, when a Russell Avenue streetcar sliding out of control on slick rails went through an open drawbridge and dropped into the ice-covered Kinnickinnic River. Motorman John W. Kennedy, age forty-two, and ten of the twelve passengers aboard scrambled to safety. Kennedy immediately dived back into the frigid water to rescue two passengers trapped in the submerged trolley. His body, along with those of schoolteacher Antoinette Ehlman (twenty-six) and Katie Schmidkunz (thirty-three), an employee of the National Knitting Works, were later recovered from the wrecked car.[121]

And on July 19, 1905, a streetcar in downtown Milwaukee was the victim of a ship collision.

The accident happened as a South Milwaukee line interurban car with twelve passengers aboard was crossing the Water Street bridge when the steamship *Kearsarge* rammed the revolving section of the span, turning it forty feet to one side.[122]

The southbound interurban car came to rest suspended precariously over the river, its front wheels just touching dry land and its rear wheels barely supported by the mangled bridge. Had the impact moved the bridge one more foot or had it been a short city streetcar rather than a long interurban

Lost Milwaukee

Streetcars on Grand (now Wisconsin) Avenue wait for river traffic at a raised bascule bridge in downtown Milwaukee.

car, the car and its passengers would have plunged into the river. Amazingly, there was only a single minor injury. A press account concluded, "Many things combined almost miraculously to prevent a terrible catastrophe."[123]

Milwaukee also boasts the first recorded case of trolley rage. In December 1946, Albert Greb, forty-three, a Milwaukee streetcar motorman, appeared in district court to answer charges of reckless driving and causing damage to property—namely, using a streetcar to demolish an automobile owned by Grant Miswald, fifty-one.

According to Miswald, the incident began after he lost control of his automobile in slick conditions. Miswald's vehicle slid into the intersection of North Seventh Street and West Vienna Avenue, where it was bumped by a northbound trolley.

Allegedly, Greb did not take the incident well. Miswald told police Greb leapt from the trolley and began beating the hood of Miswald's car with a steel switch rod while demanding the driver move his car off the tracks. When Miswald could not get his stalled vehicle to start, Greb returned to his streetcar, deliberately rammed the disabled automobile and shoved its crumpled wreckage off the tracks.

It would be nice to know Greb's account of the event, but he did not make a statement during his initial court appearance. For its part, the streetcar

company could only say Greb filed an accident report and it included a general denial of Miswald's claims.[124]

Sixty years after the original service ended, a new streetcar system is taking shape. It will be a new chapter in the city's transit history. Like all Milwaukee stories, the new system is sure to be good at times, bad at other times and occasionally just a little weird.

PART VI
STEAM AND FAST TRAINS

32
A TALE OF TWO DEPOTS

Two major railroads served Milwaukee in its formative years. The hometown favorite was the Chicago, Milwaukee, St. Paul & Pacific Railroad, also called the Milwaukee Road. Its rival, the Chicago & North Western Railway, was the first to connect Milwaukee with Chicago.

Both built substantial passenger stations, which became beloved local landmarks. As passenger traffic waned and interstate highways took hold, both were demolished.

Lake Front Depot

The North Western originally served the city from a small wood frame depot on Michigan Avenue. In June 1888, thirty railcar loads of foundation stone arrived at Milwaukee's lakefront. The stone would become the footings for a new passenger train shed. It was the first tangible sign the railway was moving forward on its promise to give the rapidly growing city a fine new station.

Built of brick and brownstone with terra-cotta ornamentation, the expansive two-story depot had an L-shaped footprint, with the main part of the structure, housing the passenger offices and waiting rooms, fronting on Wisconsin Avenue and a shorter extension containing the baggage room, the rail package service and a telegraph office facing the tracks and Lake Michigan beyond.

Steam and Fast Trains

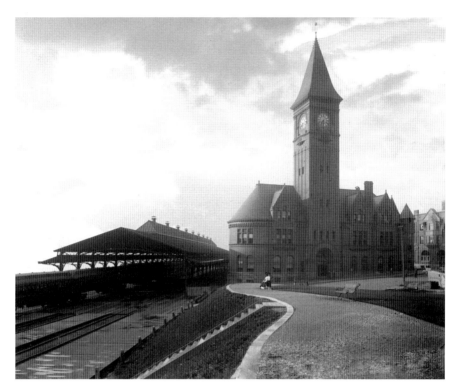

This view of Chicago & North Western's Lake Front Depot was captured around 1890. The elegant little station had unusual touches, including a bridal suite on its second floor with a view of the lake. The last train called on the depot in 1966. It was demolished two years later, becoming another example of lost Milwaukee. *Courtesy of the Library of Congress/Detroit Publishing Company.*

The depot included a restaurant, a huge fireplace in the waiting room and a hotel on its second floor, complete with a bridal suite overlooking the lake.

The location of the station was not universally admired. On January 5, 1929, the *Milwaukee Journal* took editorial note of the great beauty of the lakefront and its potential for becoming a civic asset, adding, "Meanwhile, a railroad runs through the present park and its proposed additions. So again Milwaukee has opportunity to regret this blight on its lake front."

The railroad ignored the criticism and even spent $60,000 to remodel the station in 1941, improving its main entrance and adding "modernistic decorative schemes" (lighter colors and covering the waiting room walls with glazed brick).[125]

The years passed, and then, shortly before midnight on Sunday, May 15, 1966, train no. 125 pulled into the Lake Front Depot, ending its scheduled

run from Chicago. Its passengers filed through the waiting room, and when the last had gone, the lights were switched off, the doors were locked and the station fell silent. It had seen its last train.

There was talk of saving the Lake Front Depot, or at least preserving its distinctive clock tower, but those efforts ultimately came to nothing. Local officials seemingly had little interest in preserving a building that no longer had an apparent use. The railway had already sold the station and its surrounding land to Milwaukee County for $7 million. The purchase was to facilitate construction of a lakefront freeway, which never materialized.

Newspaper reporter Charlie House described the station in 1968 as it awaited demolition:

> *The 78-year-old building, once a symbol of affluence and progress in Milwaukee, has ceased to serve its historic purpose as the city's gateway. The striking clock tower thrusts itself for 234 feet into Milwaukee's skyline. But it languishes in shabby elegance, used up, debased, slighted, unwanted.*[126]

Everett Street Depot

In the 1860s, Milwaukee banker Alexander Mitchell pieced together several different railroad companies into a unified system that would eventually become the Chicago, Milwaukee, St. Paul & Pacific—the Milwaukee Road.

The Milwaukee Road's passenger station was built in downtown Milwaukee. Officially the Everett Street Depot, it was also called Union Station. (In addition to Milwaukee Road, it served Wisconsin Central and Wisconsin Northern passenger trains.)

The Gothic Revival station was designed by well-known architect Edward Townsend Mix, and it boasted one of the tallest clock towers in America (at 140 feet) at the time of its construction in 1886. This station was the home of the Milwaukee Road's Hiawatha passenger trains, among the fastest passenger trains in the world in their time. On a test run in 1935, a steam-powered Hiawatha made headlines when it was officially timed at a steady 112.5 miles per hour for 14 miles while in the train's dining car, "a full glass of water held every drop."[127]

Even in diesel days, riders would routinely experience the thrill of their train topping eighty miles per hour and still accelerating hard as it entered a

Steam and Fast Trains

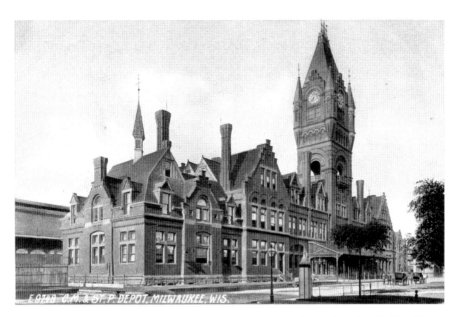

The downtown depot built by the Milwaukee Road stood at the south end of Zeidler Union Square Park.

stretch of one hundred miles per hour running. The railroad's own employee timetable was an open-ended invitation for speed-minded engineers. It mandated a ninety-mile-per-hour maximum speed for the its fastest trains with the caveat, "except where the schedule permits a higher speed."

The graceful depot was replaced by a new facility on West St. Paul Avenue (today served by Amtrak) in 1965. A week after the old station closed, it was severely damaged in fire of suspicious origins and razed soon afterward.

One of its clock faces survives. The restored mechanism forms part of the façade of the Betty Brinn Children's Museum, which opened in 1995 at O'Donnell Park, where Wisconsin Avenue meets the lake.

That Milwaukee Road station clock tells time at the former location of the North Western's Lake Front Depot, symbolically linking the two lost stations.

33

FOUR HUNDRED MILES IN FOUR HUNDRED MINUTES

Most users of Milwaukee's Oak Leaf Trail running from the lakefront northwest through the city are aware, or could easily guess, they are using an old railroad right of way. Few realize this was once the route of one of the fastest long-distance passenger trains in the world—the Chicago & North Western Railway's 400, a train named after its scheduled running time of four hundred minutes over the four hundred miles of track between St. Paul, Minnesota, and Chicago—including all station stops in between.

In the 1930s, Wisconsin was the world leader in high-speed trains. Back in the depths of the Depression, the Milwaukee Road's steam-powered Hiawatha passenger trains between Milwaukee and Chicago routinely cruised at more than one hundred miles per hour. You got to Chicago by train in seventy minutes in those days. (Today's Amtrak Hiawatha service requires ninety minutes to cover the same route.)

During a 1941 ride between Milwaukee and Chicago, railroad historian Jim Scribbins timed the nine-car steam-powered passenger train he was riding and tallied thirty-one consecutive miles at one hundred miles per hour or better, with a subsequent one-hundred-mile-per-hour burst for eight additional miles. Just another day on the Milwaukee Road.[128]

And then there was the North Western's own speed champion, the 400. In 1935, when the train made its first runs, there was nothing faster on rails averaged over such a long distance.

Steam and Fast Trains

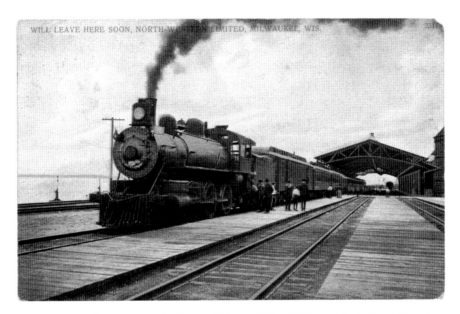

A steam-powered passenger train departs Chicago & North Western's Lake Front Depot heading north toward Shorewood.

Powered by steam locomotives—Class E2 Pacifics with seventy-nine-inch driving wheels to be precise—the train was governed by a timetable that mandated strict speed limits for junctions and certain curves but, significantly, set no maximum speed limit for the long straightaways across central Wisconsin. Crews understood the meaning of that plainly enough: they were to run as fast as necessary to stay on schedule. The railway acknowledged 110 miles per hour was common on some stretches.

This would have been reckless on almost any other steam-era railroad, but the C&NW prided itself on safety. The year before the 400 debuted, the railway rebuilt much of its mainline north of Milwaukee with heavy rail and new ballast, super-elevated the curves for high-speed operation, then inspected every inch of track with a specially fitted rail car able to detect any minute cracks in the rail.

As an added safety measure, the railway added a footnote to its employee timetable: "Nos. 400 and 401 are superior to all trains. Freight trains, transfer trains, and switch engines must clear the schedule of Nos. 400 and 401 fifteen (15) minutes." In other words, everything else on the railroad stepped aside well before the trains were due and remained tucked away until they were safely past.

The new service was a sensation when launched in 1935. Each evening, when the train departed the lakefront, Shorewood police officers guarded the Capitol Drive railroad crossing. As many as fifty automobiles would be parked alongside the road there to witness the 400 flash past, "their occupants anticipating the Minneapolis-bound streak of black lightning," Scribbins wrote.[129]

Diesel-powered 400s arrived in 1939. The name had become so famous that C&NW added "400" to the names of most of its other long-distance trains, giving Wisconsin trains like the Flambeau 400 and Peninsula 400, while the original train was renamed the Twin Cities 400. The name may have changed, but the train itself remained fast and comfortable, with a dining car service famed for excellent meals. Amenities like parlor cars and lunch counter/tavern cars were also present, as well as more personal touches.

In 1936, Chicago railroads held a beauty competition, with each company electing a queen to represent its railroad. Dorothy Whitt, an office worker, was named that year's queen of the C&NW. Soon afterward, Whitt took on a new and much more challenging assignment. She was one of the first two stewardesses assigned to the 400s.

Bicycles have replaced steam-powered passenger trains on a right-of-way once home to some of the fastest trains in the world.

Railroad stewardesses helped mothers traveling with small children, assisted passengers in making connections, booked seating times in the dining car, sent telegrams and kept a watchful eye on children traveling without a parent.

In 1961, the C&NW petitioned the Interstate Commerce Committee seeking to discontinue the Twin Cities 400, which was then losing over $1 million a year. Times had changed. Airlines were faster, and private automobiles were the first choice for most travelers. In 1963, the train made its last run.

Although it travels a different route, Amtrak's daily Empire Builder still links Milwaukee and the Twin Cites by rail. It takes just over nine hours to get there. Sixty years ago, the trip took six and a half hours.

The Oak Leaf Trail is a great place for a bike ride. And if it's haunted at all, the ghosts are whispering, "Pedal *faster*."

34
THE BEER LINE

Six decades ago in the Riverwest neighborhood on Milwaukee's north side, a kindergarten boy stood at the edge of the Fratney Street School playground and watched a steam locomotive struggle past with a seemingly endless train of railroad cars.

"Those engines would shake the school," Jim Albrecht said. "I would put my hands over my ears.... The whistle was so loud, and they blew for every crossing."[130]

When Jim began watching trains in the years following World War II, railroads had already been a part of Milwaukee for nearly a century. In fact, today's Beerline recreational trail follows one of the oldest railroad right of ways in the state.

The Milwaukee & Waukesha, chartered in 1847 with construction beginning two years later, was the state's first railroad. In 1852, a second railroad, the La Crosse & Milwaukee, started building northward from its terminus at North Third Street and Highland Avenue on the west bank of the Milwaukee River. The line followed the river alongside Commerce Street to its engine terminal and railroad yard at the southeast corner of North Avenue and Humboldt Boulevard. From there, the line ducked under the North Avenue viaduct and climbed the river bluff to today's Gordon Park, and turned northwest through the Riverwest neighborhood.[131]

In 1869, the two railroads were joined by via a north–south connector track between the former M&W in the Menomonee Valley and the La Crosse & Milwaukee at North Milwaukee Junction near Thirty-Second and Hampton.

Steam and Fast Trains

The state's second-oldest railroad right of way (it dates to the 1850s), the Milwaukee Road's "Beer Line" is now a recreational trail.

With the linking of the two railroads, the former La Crosse & Milwaukee main line through Riverwest became a 6.2-mile branch line officially called the Chestnut (since renamed Juneau) Street Line.

Although relegated to branch line status, the railroad through Riverwest was destined to play a significant role in the new Chicago, Milwaukee, St. Paul & Pacific Railroad. This short section of track generated more freight revenue per mile than any other part of the vast system. With three major breweries, Schlitz, Pabst and Blatz, near the southern end, the branch soon acquired the nickname "Beer Line." Certainly, beer was big business for the line. On some days, the breweries loaded more than 250 railroad cars. There were many other customers along the line. Except for a few residential blocks at the northern end of Riverwest, the Beer Line was lined with heavy industry, including the Nash (later American) Motors Seaman Body Plant on Capitol Drive, which required 35 to 50 freight cars a day. Other major shippers included Continental Can and Schuster's Department Store (which had a warehouse on Commerce Street).

Steam locomotives were replaced by diesels in the 1950s, but train after train rolled through Riverwest.

Jim Albrecht recalls counting as many as one hundred cars in some trains—a moving wall of steel nearly a mile long. In the 1940s and 1950s, Albrecht said, the railroad maintained a tiny crossing shanty at the corner of Locust and Humboldt. As the trains approached, an elderly man would emerge from the little shack and wave a sign to stop traffic. A heavy train climbing the river bluff from North Avenue would take ten minutes to struggle through the intersection, posing a real problem for emergency vehicles that needed to get through.

The Beer Line grew up with the brewing industry, and it faded when brewing drained from the Milwaukee scene. Blatz closed in 1959. Schlitz, which once accounted for hundreds of carloads a day, began to unravel, finally closing in 1981. Pabst, never a major rail shipper, also gave up on rail service. In the mid-1970s, American Motors sharply scaled back production at its Capitol Drive facility. By the 1980s, the plant had shut down. By then, the Milwaukee Road itself was in a death spiral, soon broken up and sold off in pieces.

Under new owners but starved for business, the Beer Line slowly retreated from downtown, ending 130 years of service on the historic line. The city and county reclaimed much of the right of way in recent years and opened the Beerline Recreational Trail.

35
AN UPRIVER MYSTERY

Before there was a grocery store at the corner of Humboldt Boulevard and North Avenue, there was a railroad yard. Older residents recall weed-overgrown tracks and the occasional idling diesel locomotive. Long before that, however, this was a point of intense local pride. In the mid-1850s, the intersection was the site of the main repair shop and roundhouse for Byron Kilbourn's La Crosse & Milwaukee Railroad, the second-oldest railroad in Wisconsin.

And here a baffling series of crimes took place. In time, a solution was found, but the perpetrators were never brought to justice.

The following story may be found in a collection of essays published in 1901 by the Old Settlers' Club.[132] By "Old Settlers," the club meant exactly that: its membership included the original residents of the city who gathered to share memories of Milwaukee's very earliest days.

In 1899, member Jeremiah Quin, a former railroad blacksmith, stepped to the club's podium to relate the bizarre events:

> *In the autumn of 1858, an occurrence just above the dam caused much annoyance to the squatter settlers of that region. The La Crosse shops were running in full blast. The long brick blacksmith shop on the crest of the river bank was full of vigorous, brawny men, many of whom built small houses, known as shanties, along the river banks.*

In those days, the blacksmiths had a custom of wearing red flannel shirts to work. They were highly skilled men, and they considered their red shirts

a hard-won badge of office. This attitude extended to blacksmiths' wives, who, Quin said, could be identified on wash days by their proud bearing as they laid red shirts out to dry on the sunny, grassy banks of the river. Quin continued:

> *All at once a dark cloud came over the sylvan spot. A red shirt began to disappear here and there from the variegated lawn, and no one could discover how. Day by day, the crop of red shirts grew less and less, and what deepened the mystery, was, that while there were garments of various hues, of gauzy textures and costlier finish, lying on the daisy-covered sward, only the red flannel shirts were ever taken.*

The blacksmith families advanced many ideas of how and why the thefts were happening, and organized themselves into a vigilance committee, likely Milwaukee's first neighborhood watch. Still, the red shirts continued to vanish and the mystery only deepened.

One young woman swore she had watched the drying shirts intently. Seeing no one either up or down the riverbank, she turned to glance at the bluff behind her. Turning back, just seconds later, she discovered one of the shirts had vanished.

Neighbors concluded she had fallen asleep and would not admit it.

One day, Quin said, an unfortunate ragpicker happened to walk through the little community and was immediately surrounded and ordered to unload his huge bag. The contents were carefully examined, but nothing in the way of red flannel was found and the man, badly frightened and rather puzzled, sent on his way.

In the end, there was only one thing to do, and the blacksmiths did it. Red was abandoned in favor of blue shirts, and the thefts stopped.

But then, Quin added, an answer came to light:

> *The long winter passed, and when the warm sun of Spring melted the crested snows of the stream, the mystery was solved. Well up towards Humboldt* [he refers to the old town of Humboldt, near today's Capitol Drive bridge] *a colony of muskrats made settlement that Winter. Their vast network of nests looked as usual, until the warm Spring rays all at once metamorphosed the scene, and strange to relate, in a single day the colony assumed the appearance of a miniature English military camp, and a most picturesque sight it was, too; every nest was crowned—capped with a red flannel shirt.*

PART VII

LOST RIVER LANDMARKS

36

A RIVER MADE FOR RECREATION

The North Avenue dam, built in 1843, divided the Milwaukee River into an industrialized lower river through downtown to the harbor and a relatively untouched upper river, which became a center for recreation for the growing city. Here, from the late 1800s to World War I, you could take a steamboat from North Avenue up the river to visit a beer garden or an amusement park. For the more energetic, there were businesses at both ends of the North Avenue Bridge renting canoes and rowboats by the hour or by the day.

And there were boat clubs. The *Milwaukee Sentinel*, in a September 4, 1912 article, listed twenty boat clubs on the upper river with a total membership of around three hundred. The clubs had names like White Squadron, Pleasant Valley, La Fa Lot, Sun Set and Shady Nook. If the article had been written a few years earlier, it would have included the Daphne Boat Club.

In a 1935 newspaper article, Daphne member Lansing Robinson shared his memories of an era when canoes were king on the upper river.[133]

The Daphne Boat Club's two-story clubhouse was on the eastern bank, just above the North Avenue Bridge in an inlet called Bullhead Bay. Now filled in, the inlet was located at the foot of East Thomas Avenue. The ground floor of the Daphne Club's two-story building provided storage for club boats—including an imposing sixty-foot vessel able to accommodate ten oarsmen and fourteen guests. The club also owned a pair of four-oar boats and three racing shells (a four-oar, a double and a single). The building's upper level included a social hall, lockers and dressing rooms.

Lost River Landmarks

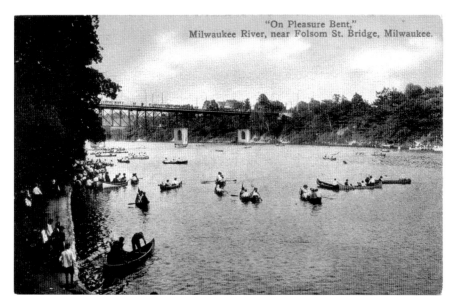

Canoes crowd the Milwaukee River at Gordon Park on a fine summer day in the early 1900s to watch an aquatic contest.

Scotty Dore was club president. A notorious practical joker, he once was rowing in a double with another member and deliberately capsized the craft. As he swam to shore, he heard cries for help. He belatedly remembered the other man was unable to swim. He swiftly returned and towed the man to safety. On another occasion, Scotty, stepping from a boat at the club's floating dock, noticed another member kneeling at the edge. As he passed, he playfully shoved the man into the river. He "went down like a rock," Robinson wrote. Scotty recalled that this man, too, was not a swimmer. He dived in and pulled him out.

This led to a tongue-in-cheek suggestion the club award Scotty a medal for saving the lives of the two members.

Contests between canoe clubs were popular events. In 1938, for example, more than five thousand attended a two-day water sports show sponsored by the *Milwaukee Journal* on the river between Kern and Hubbard Parks. In addition to rowing races, that event included half- and one-mile marathon swimming contests and was capped by a motorboat race.[134]

Popular as that event was, it was dwarfed by the annual Venetian night water carnival sponsored by the canoe club association. In 1913, a reported fifty thousand spectators crowded both riverbanks between Blatz Park beer

garden at the foot of East Concordia Avenue and Riverside Park to watch the festivities.[135]

"As twilight came on lights began to twinkle along the shore and lighted Japanese lanterns appeared on the canoes," the *Milwaukee Sentinel* reported. "Soon a long line of lights could be seen far down the river, slowly approaching the Folsom [later renamed Locust] Street bridge. As it came nearer the mass of illumination separated into individual lights and the parade was passing the pavilion of Riverside Park."

The winner of Venetian night water carnival that year was the entry of the Pleasant Valley Canoe Club—a barge disguised as a small island complete with trees and shrubbery:

> *In the center of the float was a small fire—a campfire it proved to be when the judges could see the eight figures squatted around. Lolling about, as if they were just ready to retire to their tents for the night, were a group of canoe campers, clad in any old thing for comfort's sake, smoking pipes and looking as if they were fifty miles from anywhere with nothing but wilderness around.*[136]

"The upper river was handy," wrote *Milwaukee Journal* reporter Robert W. Wells. "It was Milwaukee's principle playground, with dancing, band concerts, swimming, boating, fishing, and, on special occasions, a touch of Venice."[137]

The Daphne Club was an all-male institution, but women commonly rented boats for a strenuous day's outing on the river and the all-female Milwaukee-Downer College offered competitive rowing as part of its athletic program starting in the 1890s. The college's fiercely contested annual regatta was a major event on the river.

The Daphne Club closed in the 1890s when members were unable to keep up on maintenance, but other groups remained active for a few decades. One organization, the Milwaukee Rowing Club, founded in 1894, continues to this day.

Recalling his boat club of more than forty years before, Robinson concluded with this memory of the days when pleasure boats crowded the river:

> *The black barge had room for ten oarsmen.... The seats were staggered and allowed space for a passenger beside each oarsman. We gave frequent barge parties with a ride up to Luddemann's-on-the-River for a supper of boiled*

chicken or whitefish, green peas, French fried potatoes, beer. Then after a bit of dancing we rowed down the picturesque river in the moonlight or starlight, with a girl seated alongside each man, and everybody singing to the rhythmic sweep of the oars, "Seeing Nellie Home," "Merrily We Roll Along," "Good-night Ladies," "Down Mobile Bay," and other suitable glees of the late Victorian period. Some of the boys met their fate on those rides, and although the old voices may squeak a bit now and then, they are still singing to the same girl.

37
MILWAUKEE CEMENT COMPANY

Estabrook Park, on the east bank of the Milwaukee River north of Capitol Drive, has an odd claim to fame. It rests on an unusual layer of pale gray Devonian limestone. An excellent natural cement, this rock was extensively quarried a century ago, and the operation forever altered this stretch of the river.

It all started when ordinary-looking rocks casually left on a desk were seen by possibly the only man in town who understood their significance.[138]

In 1873, Joseph Berthelet, a Milwaukee manufacturer of cement sewer pipe, dropped by the city engineer's office and noticed rock samples excavated as part of the construction of the North Avenue bridge. Berthelet thought the rocks looked identical to the natural cement limestone he had seen while purchasing cement from a mill in Louisville, Kentucky. There was one way to be sure. He quietly collected samples of his own. In his kitchen that night, he burned the limestone until it was semisoft and ground it into powder. He added enough water to make a paste, which he formed into little balls and flat cakes. Some he dropped into water, and others he left out to air-dry.

The next morning, all the samples, even the ones that had spent the night underwater, were rock-hard—harder, in fact, than the original limestone. At that moment, he knew part of the city of Milwaukee was sitting on a rare and very valuable deposit of hydraulic cement limestone.

Now Berthelet needed to find where the rock was both close to the surface and on land available for purchase. After a long and solitary search by horse and buggy, he found the place he was looking for. Along the river

Lost River Landmarks

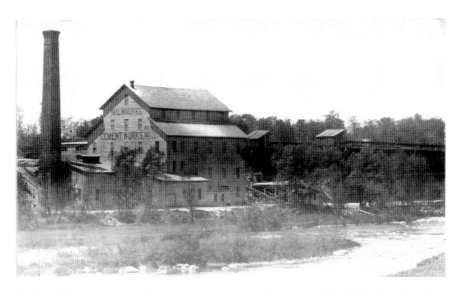

Estabrook Park was once an immense cement quarry, the largest of its kind in the United States, and its impact on the land can still be seen.

just north of today's Capitol Drive, he saw the limestone shelf emerging from low banks.

He shared his discovery with a few trusted friends in the business community. The men pooled their funds and formed the Milwaukee Cement Company. The new firm soon arranged to buy most of the east bank of the river from Capitol Drive to Port Washington Road—today's Estabrook Park.

In 1876, the company installed a grinder and kiln in a ravine south of the present-day dog exercise area, and 350 workers started digging rock from horizontal and vertical shafts. More kilns boosted production to two thousand barrels a day. A little community complete with a post office sprang up. Officially named Berthelet, Wisconsin, it was generally called Cementville.[139]

With business booming, the company acquired the land on the west bank of the river and built a second mill, also with a daily capacity of 2,000 barrels. By 1891, annual production reached 475,000 barrels (about 125 million pounds), and Milwaukee Cement was the largest producer in the United States.

Noticing that the river had done the work of topsoil removal, the company diverted the channel and quarried the riverbed. The result was a pair of man-made lakes, the larger named Cement Lake and the smaller named Blue Hole.

Rivals soon appeared. The Cream City Cement Company, backed by German-language newspaper publisher George Brumder, bought land and built a kiln just a quarter mile from Milwaukee Cement.

Cream City Cement's unfavorable location meant workers needed to dig deep vertical shafts to reach the limestone. Production was modest, at about two hundred barrels a day. In 1894, Milwaukee Cement purchased the failing Cream City Company and closed the mill and its system of tunnels.

A third company, Consolidated Cement, established a mill on the shore of Lake Michigan in Fox Point, but it soon closed.

Just when things couldn't go any better for Milwaukee Cement, it came crashing down.

The invention of the rotary kiln produced a superior type of cement, known as Portland cement, from common materials. As availability spread, demand for natural cement fell. By the early 1900s, Milwaukee Cement was limping along as a distributor of Portland cement and leased its two mills for production of silica products. A fire destroyed one mill in 1910. In 1914, the second mill burned.

As its final act, the company sold off its land holdings. Milwaukee County gained the east bank for park use. The west bank sold in parcels to various manufacturing companies.

Left behind was a much-altered landscape.

Estabrook Park visitors were once able to explore the maze of abandoned shafts and caves. Several children lost their lives by wandering into the caves during winter, stepping on thin ice and plunging into shafts filled with deep water. Problems continued even after the park sealed the entrances. In 1960, a section of underground mine collapsed, causing a sinkhole the size of a residential lot.

But the most visible sign of mining activities was on the west bank. The company had confined the Milwaukee River to a channel east of its original course, then dug an immense quarry on the former riverbed. After operations ended, the quarry flooded forming a pair of large man-made lakes, Cement Lake to the south and Blue Hole to the north.

Many Milwaukeeans liked to cool off by swimming in the deep, spring-fed quarry lakes. But their sudden drop-offs, underwater ledges and submerged caves claimed many unwary swimmers. Blue Hole gained an especially sinister reputation and the nickname "suicide hole."

The fate of thirty-acre Cement Lake would be the subject of heated debate for many years. In the 1920s, the city acquired part of the west bank and started filling the lake with rubbish. Many, including land commission

member C.B. Whitnall, urged the lake's preservation. The *Milwaukee Journal* agreed in a 1929 editorial:

> *Why select a picturesque section of the river for a public dump? To be sure, dumping grounds must be found somewhere. Nor can the commissioner of public works be blamed if he becomes irritated when, having found an out-of-the-way dumping ground, someone comes along and wants to preserve it for its beauty and utility. The two banks at this point, however, will practically be one park, and this park might have an attractive lake in its center. Such a resource should not be thrown away because it is inconvenient to find a dumping ground.*[140]

Whitnall and his supporters won a moratorium on dumping, but nothing was done to clean up the existing garbage. In the 1930s, the west bank of the river, north of city dump, was occupied by a Depression-era shantytown of twenty-five to thirty shacks made from discarded tin signs, cardboard and tar paper. Inhabitants dubbed the crude shacks on the river's edge "Estabrook Lowlands" and the ones on the top of the bank "Estabrook Highlands."

Unemployed skilled workers were included among the shanty dwellers, all of whom were united by a common refusal to accept public assistance. One of the residents, Harold Lundwall, a tool and die maker who had been without work for nineteen months, invited a reporter into his "Depression villa." A steady, cold rain was finding its way through Lundwall's improvised roof in rivulets, but a stove made from a discarded automobile gas tank kept the interior warm and snug. He told the reporter: "[I was] born and bred in Milwaukee. It's my hometown. But when a fellow's family is hard up, too…it's better this way."

In 1953, the Milwaukee Common Council's Buildings and Grounds Committee voted 3–2 to resume using the lake as a rubbish dump. The long-dormant public debate immediately picked up where it had left off, with many arguing the spring-fed Cement Lake represented an appealing water feature. But there was no reprieve. It required a million cubic yards of garbage and more than five years to fill Cement Lake. During that time, Estabrook Park visitors had a panoramic view of an ever-growing rubbish heap.

Today the paved-over landfill is a remote parking lot for the University of Wisconsin–Milwaukee, and the dream of one park on both sides of the river with a lake in the middle has vanished.

38
ESTABROOK'S LOST BEACH

Estabrook Park, on the east side of the Milwaukee River north of Capitol Drive, has much to offer. There is a disc golf course, a popular dog exercise area and an even more popular beer garden. The swimming beach, however, has been closed for seventy years.

Even on a hot day, most people would hesitate before jumping into the Milwaukee River, but it was once enormously popular for swimming. Kletzsch, Estabrook and Gordon Parks had swimming areas, and there were at least three private swim schools located near the North Avenue dam. Gordon Park, with its beautiful bathing house, is fondly remembered by longtime Milwaukeeans, while Estabrook Park's beach is nearly forgotten.

As was the case with so many beautiful and useful aspects of Milwaukee County's parks, the beach was the result of a Depression-era make-work project. The county employed seventy-five men to create a bathing beach at a spot where the river was unusually broad and deep.

In the days before there was a park, the Milwaukee Cement Company built cofferdams, first on one side of the river and then on the other, and dug horizontal mine shafts into both riverbanks before finally abandoning the operation and leaving behind a pair of huge man-made lagoons on the west bank of the river—dubbed Cement Lake and Blue Hole. These were dangerous places to swim. The former quarries were the scene of several drownings each year through the 1920s.[141]

As part of the swimming beach project, park workers tore down the abandoned cement kilns, assembled floating platforms and dumped countless

The Estabrook swimming beach was added as a Depression-era Works Progress Administration project. Little remains today.

wheelbarrows of rubble into the water to create a river bottom that gradually and predictably became deeper, moving from the shore outward.

The beach, complete with temporary bathhouse, opened to the public in June 1931. By summer 1937, the Milwaukee River had all three river swimming areas staffed with lifeguards and offered swim classes. Even so, on particularly hot days, the swimming areas could become overcrowded and cause people to look elsewhere for a cooling dip in the river despite a city ordinance that made it illegal to swim outside of designated areas. On a hot day in June 1933, Milwaukee Police arrested forty men, women, and children for swimming on the wrong side of the river from the beach at the deadly former quarry with the pretty name of Blue Hole.

The "Blue Hole raid" stirred quite a firestorm, especially since some of the swimmers actually spent the night in jail. Police defended their action, saying the river opposite the Estabrook beach was an exceptionally dangerous place, yet people persisted in swimming there despite repeated warnings and repeated tragedies.

Estabrook beach had hazards of another kind. In a letter published in the July 29, 1942 *Milwaukee Journal*, an indignant Henry Koether reported his clothing and personal effects had been stolen from the bathhouse:

> When a person is caught in such a predicament, clad only in bathing trunks and left without even the proverbial wood stave barrel for protection, he is in dire need of sympathy and help. But what assistance did I get? When I was finally able to locate the bathhouse attendant, this individual brightly ejaculated "We assume no responsibility." He waved aside my suggestion to notify the police and he displayed a general "I don't care" attitude.

Koether concluded by suggesting, reasonably enough, that bathhouses be redesigned to make theft more difficult and that public employees show a little more interest in their jobs.

Four years later, in spring 1946, the county park commission decided the swimming beach would not open for the summer, citing increased pollution

The overgrown former swimming beach at Estabrook Park. The beach closed after the 1945 season due to increasing pollution.

from industrial dumping, sewage overflows and runoff from streets. The deteriorating bathhouse, commissioners noted, was beyond repair.

One assumes Henry Koether, for one, was not sorry to see the era come to an end.

Tree growth and dense vegetation make it difficult to locate the former beach. Its old parking lot is now the park's dog exercise area.

39

A BOAT NAMED *KILLJOY*

Canoodling canoeists, riverbank lotharios and skinny-dippers here, there, and everywhere. By the 1920s, it was no wonder local newspapers had taken to calling the Milwaukee River between North Avenue and Capitol Drive "Petters' Paradise."

With public complaints soaring in the summer of 1921, Milwaukee Police decided it was time to put a damper on the watery lasciviousness. The department acquired a secondhand but rather sleek little motorboat, equipped it with a powerful spotlight and assigned enough patrolmen to man the craft with two officers daily from 8:00 a.m. to midnight. The boat set to work, with Chief of Police Jacob Laubenheimer promising local newspapers that immoral conditions would be eliminated within a week.[142]

The police didn't bother to name the craft, but young couples whose romantic interludes were interrupted began calling it "the killjoy." In a rare example of official good humor, Milwaukee police embraced the name. River patrol boats would wear out and be replaced over the decades, but each new craft was invariably referred to as the *Killjoy*.

For their part, a newspaper noted, "The canoe club members resent the imputation of immorality to them. 'Spooning,' they say, isn't immoral."[143]

Police Chief Jacob Laubenheimer said the *Killjoy* did much more than enforce morality:

> We had a rowdy element to contend with on the river. There were several tough north side gangs who used to make life miserable for respectable

citizens by stealing, fighting, destroying property and gambling. Women and children were not safe along the river. When the first police motorboat was launched this trouble was greatly reduced and in later years was completely ended.[144]

Laubenheimer was quite a forward-thinking character, and it's possible the boat patrol was his own idea. During his fifteen years as chief, he hired the department's first female and African American officers, equipped patrol cars with radios and established one of the world's first police academies.[145]

The boat proved troublesome in its first year. Less than a month after it arrived, it suffered "a chronic attack of engine trouble"[146] and had to be overhauled over the winter. Even with the boat out of service, the police kept an eye on canoe clubs. In May 1922, police raided a canoe club at the foot of Thomas Street and arrested three women, aged sixteen to eighteen, and their male escorts on charges of disorderly conduct. Police said intoxicants were flowing and the couples were embracing when interrupted. "Canoe club parties where 'petting' and 'necking' is the rule will not be tolerated, said police."[147]

Two months later, the July 24, 1922 *Milwaukee Journal* announced the *Killjoy*'s return with a memorable headline: "Canoe Spooning Off: Police Boat Fixed."

The officers manning the *Killjoy* were trained in lifesaving and first aid. Daytime duties included watching for swimmers in distress. During its four decades of operation, the patrol saved countless lives. Patrolman Erwin Riemer recalled:

> *One day in summer day in 1926, a young couple attempted to swim across the river at the foot of Meinecke Avenue. They were three-quarters of the way across when both became exhausted and started floundering. I was working alone that day and had gone by just before they got in trouble.*
>
> *I happened to look back and saw the boy, who was about 17, and the girl, about the same age, waving their hands in the air and swallowing water. I turned the boat around, pulled alongside, managed to drag both into the boat, and took them ashore.*
>
> *After 15 minutes of artificial respiration both recovered. Neither one of them even said so much as "thank you!"*[148]

On another occasion, a man attempted suicide by jumping from the Locust Street bridge. He landed feetfirst in a shallow spot and found himself

up to his waist in mud and up to his neck in water. Trapped but unharmed and having second thoughts about ending it all, he was bellowing for help when the *Killjoy* arrived.

At night, the boat cruised along slowly and quietly, on the lookout for trouble and occasionally living up to its name by turning its spotlight on drifting canoes and furtive activities on the riverbanks. For example, in the early morning hours one Sunday night in June 1925, six people found themselves charged with disorderly conduct.

According to a newspaper report, "The youths arrested are members of the Belle Isle Canoe Club. They danced until midnight with their sweethearts, then—despite the pouring rain—ventured out in canoes. Irvin Karnatz, commander of the river patrol boat *Killjoy*, followed the three canoes and saw petting parties which he believed to be disorderly. He gave chase and ordered the canoes to pull to the curb—pardon, bank."[149]

Officers assigned to the *Killjoy* knew many of the people frequenting the river by sight and were adept at spotting strangers who were up to no good. And when trouble was reported, the *Killjoy* would be on the scene in a flash—the boat was fairly fast, and its patrol area covered only two miles of river north of the North Avenue dam.

The first *Killjoy* was destroyed in a fire in 1926, but a new boat was ready for service when the river thawed in spring 1927. In 1928, it moved to a purpose-built two-story boathouse south of the Gordon Park bathhouse. In 1936, the police requested a replacement boat and specified one capable of thirty-two miles per hour. The city purchasing board, being a bit of a killjoy itself, felt the wake from such a fast-moving boat would endanger canoeists and ordered a slightly more sedate craft.

The river patrol was mothballed in 1939, but regular patrols resumed in 1944 after a spate of drownings on the upper river. Patrolmen at the time were instructed to warn swimmers under the age of eighteen to be extra cautious. Unaccompanied small children swimming in the river were to be immediately marched home to their parents.

By 1948, things on the upper river were getting rough. Police were frequently targeted by rock-throwing youths from the riverbank. Matters escalated to the point where numerous fifty-five-gallon drums were stolen, filled with rocks and tipped into the river in the hope the *Killjoy* would strike the submerged drums and sink. (This boat, being radio-equipped, was now also known by its call sign of Squad 55.) The boat never did sink, but it usually broke a few propellers each summer on the underwater obstructions.

The last *Killjoy*, an eighteen-foot Chris-Craft, was placed in service in 1956 and patrolled into the 1960s. In May 1961, the *Killjoy* was assigned to protect rowing crews from Milwaukee-Downer College, who reported coming under BB gun fire. After a two-day stakeout of the riverbank, police apprehended two boys who admitted firing the shots.

The river patrol was the forerunner of today's Milwaukee Police Department Marine Operations Unit, which watches over the city's lakefront and harbor areas.

According to a police spokesman, the department's current patrol boats are not named, but perhaps it's appropriate the *Killjoy* designation faded from use with the end of forty years of service on the upper river.

40
A DUCK NAMED GERTIE

In the waning days of World War II, Gertie, a mallard duck who hatched her eggs on a bridge piling in the heart of downtown, became Milwaukee's best-known resident. Updates on the duck's activities made front-page news for a full month in spring 1945. She was featured on the cover of *Life* magazine, profiled in *Reader's Digest* and the subject of a prime-time television show in 1963. And a children's book retelling the story of Gertie sold more than a million copies.

To understand the impact a small, wild duck made on the city, turn the clock back seven decades.

In spring 1945, World War II was drawing to a close. Allied forces were advancing steadily through Germany and closing in on the Japanese home islands. After years of food and fuel rationing, war bond and scrap metal drives and sad news from distant battlefields, Milwaukeeans were ready for a change.

In late April 1945, a bridge tender assigned to the Wisconsin Avenue lift bridge called the *Milwaukee Journal* to report a mallard duck had built her nest ten feet above the river on the hollow top of a rotted timber piling next to the busiest bridge in Wisconsin.

Writer Gordon MacQuarrie dropped by to see for himself and wrote a lighthearted account for his paper, noting, "The bridge operators can hardly wait to see the old lady hatch out the ducklings."[150]

That story—with daily updates for the next thirty-seven days—created a sensation. Wire services spread the articles nationwide. Even *Stars and Stripes*,

Lost River Landmarks

A statue of Gertie the Duck stands guard over her ducklings on the Wisconsin Avenue bridge, seventy years after the real Gertie captured national attention.

a publication for members of the armed services, reprinted the daily duck reports in serial form. Two members of the U.S. Army Air Corps stationed in England, Nicholas Georgiady and Lou Romano, followed the news with special interest. Milwaukee was their hometown.

"Anything catching the more human side of living was a nice relief," Georgiady recalled.[151]

Journal reporter MacQuarrie gave Gertie her name, although writers for the rival *Milwaukee Sentinel* persisted in calling her "Mrs. Francis Drake."

Gertie laid her eggs, one a day, oblivious to the ever-growing crowd of onlookers and the hammering din of streetcars crossing the steel bridge.

Milwaukeeans took Gertie to heart. A planned project to replace the rotted pilings was put on hold. City officials, concerned by an oil slick in the river, ordered the pumping of an additional five million gallons of lake water to flush the river clean. On Mother's Day, hundreds of cards were mailed to the duck. Marching bands in the annual Memorial Day parade stopped playing as they reached the bridge and walked across in silence to avoid disturbing Gertie.

Gertie sat on her eggs, Milwaukee's thronged the bridge and the walk next to Gimbals and looked at her. Watching a mallard brood might not strike a resident of New York, San Francisco, or even Chicago as an exciting way to spend a Spring afternoon. But this was Milwaukee, the looking was free and for ten days her fans looked at Gertie and Gertie looked at them and everyone was content.[152]

MacQuarrie recounted a conversation with a long-distance trucker who had stopped to see the nest while driving a load from Chicago to Sturgeon Bay. It was the second time he had seen Gertie, the truck driver explained. He hoped the eggs might hatch while he was there, for it would be a week before he would be back in the area.

"As if in response to this attention," MacQuarrie wrote, "Gertie slowly raised from the six famous eggs to carefully shift them with her adroit bill… then settled back on the eggs with the now-famous wiggle that never fails to bring laughs from the gallery."[153]

Soon afterward, the eggs began to hatch. Almost immediately, one newborn duckling, dubbed "Black Bill," got into trouble. Staggering around the piling while onlookers gasped and screamed, he fell ten feet to the river below making, we are told, a very small splash.

The on-duty bridge tenders, Paul Benn and George De Graace, scrambled into a rowboat. Black Bill could swim just fine, and he led the men on a zigzagging chase back and forth across the river. Finally, they were able to scoop him up with a long-handled net and return him to the nest. "You understand," MacQuarrie wrote, "by this time, 2,000 persons on the bridge were hysterical."[154]

That night, a violent storm blew in. At midnight, in the wind and rain, Black Bill and a sibling went over the edge. The bridge tenders, Fred Schultz and Alex Rehorst, spotted two ducklings in the river, two other rain-soaked ducklings and a partially hatched egg on the nest and Gertie nowhere in sight.

Rehorst, Schultz and the trusty rowboat swung into action. The two swimmers were rescued. A short time later, the ducklings fell in again. The worried bridge tenders called Larry Hautz of the Izaak Walton League, who arrived at one o'clock in the morning and moved the four surviving ducklings and the partially hatched egg into the warm bridge house. In the meantime, Rehorst and Schultz found Gertie and brought her into the bridge house.

Hautz examined the partially hatched egg. Gently, he broke away the shell to reveal a cold—but still alive—duckling. Hautz lined his hat with wads of

cotton, placed the little bird inside and set the hat on a chair before the open door of the coal stove. All through the night, he watched over the little duck, periodically removing it and rolling the bird in dry corn flour to absorb moisture from its feathers.

The account of Black Bill's misadventures, the rescues performed by the bridge tenders, the wild storm and Hautz's fretful watch over a sickly bird were detailed at length in the June 1, 1945 *Milwaukee Journal*. Total American casualties for World War II, noted a separate story in the same day's paper, had surpassed the one million mark.

In Milwaukee, five ducklings were alive, but a sixth had disappeared in the stormy night. Clearly, the piling was no place to raise a family. The nearby Gimbel's Department Store offered the use of a display window and hired three registered nurses, working rotating eight-hour shifts, to continually monitor the temperature and humidity of Gertie's new home.

On June 4, 1945, Gertie and her family were released into the Juneau Park lagoon. City officials estimated Gertie had been viewed 2.6 million times in just over a month and a half.

Later, when MacQuarrie visited the lagoon, he realized there was no way to tell which of the park's many ducks was the famous Gertie.

Nicholas Georgiady and Lou Romano, the two homesick airmen who followed Gertie in the pages of *Stars and Stripes*, returned home after the war. Both became schoolteachers and worked together co-writing educational materials. They produced 105 children's books, several filmstrips and 7 textbooks. In 1959, the men wrote a children's book called *Gertie the Duck*. It became a bestseller.

Romano said, "It gives Milwaukee a wonderful, warm feeling—that a whole city would go crazy over a duck and her family."[155]

Back on May 7, 1945, when Gertie was still sitting on her unhatched eggs and war still raged, the *Milwaukee Journal* printed this editorial:

> *Gertie is part of nature's clean and beautiful world, unspoiled and undisturbed by man. She is no specimen in a zoo, no clipped wing prisoner of a park. Unawed, Gertie settled right down here in the middle of the city because she liked it.*
>
> *And Gertie has taken our minds off some of the ugly things around her; she even helps us forget, for a few minutes, the horrible bungle man has made of his world.*

41

THE LOST NEIGHBORHOOD

Just north of the Locust Street bridge, Cambridge Woods Park narrows, squeezed between the Milwaukee River and a former railroad right of way that now hosts the Oak Leaf Trail. Tightly spaced crumbling concrete foundations can be seen along the riverbank, some covered with graffiti, some barely more than rubble piles amid the weeds and wildflowers.

This is all that remains of River Colony, one of the most unusual neighborhoods in Milwaukee.

The residents had electrical service, a sewer system, and water from the colony's own well. What they lacked was an easy way in or out. In the winter, residents could simply drive their cars across the frozen river and park at their doorsteps, but in the summer, they had to park on Cambridge Avenue, cross Locust Street, descend a flight of wooden stairs to a tiny railroad passenger platform and cross three sets of tracks before finally arriving at home.

It must have been a very peaceful place to live, apart from the passing trains, although not quite as bucolic as you might think. If you were to go back in time and look across the water from these houses, your view would have included, going from south to north, the towering Locust Street bridge, a massive icehouse operated by Random Lake Ice Company, a large City of Milwaukee pumping station and twin icehouses owned by the Schlitz Brewing Company.

This odd corner of Milwaukee attracted newspaper attention in 1935 when the Chicago & North Western Railway decided to get rid of its Folsom Place depot. ("Folsom" was the former name of Locust Street and, almost

Only foundations remain of River Colony, a half-dozen homes on the east bank of the Milwaukee River north of the Locust Street bridge.

under the south side of the Locust Street bridge, the railroad maintained a passenger stop served by two trains a day.) Service to the depot ended in the Depression, and the railway applied to the Public Service Commission to abandon the unused station. This proposal worried residents of River Colony. If the railroad removed the stairs, they would have to climb the steep clay hillside, difficult enough on a nice day but muddy and slippery in the rain.[156]

Members of the commission and railway officials proved sympathetic and agreed. No matter what ultimately happened to the disused station, the staircase would stay.

In the mid-1960s, residents vacated their homes as plans moved forward to build a four-lane parkway along the former railroad right of way from the then-planned Lake Freeway north to a connection with the planned Bay Freeway, near Hampton Avenue. The parkway would have followed the east bank of the Milwaukee River between North Avenue and Hampton Avenue, passing through Riverside, Hubbard

and Estabrook Parks. The parkway was designed to carry forty-seven thousand cars a day and would have had a speed limit of fifty miles per hour on some sections.

Opposition from residents, as well as preservation groups seeking to protect the river from extensive development, killed the plan in 1970. (Farther north, the Bay Freeway ran into similar opposition and was also never built.)

A substitute proposal for a two-lane "pleasure parkway" with a speed limit of twenty-five miles per hour—similar to existing river parkways in the county—was put forward and also eventually rejected. By then, only the foundations remained of the homes that once lined this section of the river.

It's cool here under the trees, and the river is hypnotically soothing. It's a nice place to visit, but would you want to live here?

42

AMID THE RUINS

Deep in the trees along the west bank of the Milwaukee River near the Locust Street bridge is a strange sight: a century-old concrete retaining wall, with two sets of stairs leading down into a field of tall grass. The wall is all that remains of the Gordon Park bathhouse, a point of considerable civic pride when it opened one hundred years ago but ultimately cursed by its location and by steadily worsening water pollution.

Before building the bathhouse, the city park commission tested the popularity of the swimming area. In 1911, commissioners noted:

> *A public bathing beach was started as an experiment on the river at Gordon Park. Six election booths were erected on the riverbank, dressing rooms were partitioned off, and an attendant for the boys and another for the girls, were employed; the man in charge acted as life-saver. This bathing beach and the booths were put in order rather late in the season, but during the 45 days they were in use, 10,792 boys and 508 girls availed themselves of the sport. The advantages the river has over the lake as a bathing beach is that it gets warmer sooner and that the temperature remains more even.*[157]

Built in 1913 at a cost of $25,000, the Gordon Park bathhouse opened for swimming in summer 1914. It contained an eating room and more than three hundred lockers, accommodating as many as six hundred swimmers at a time. The bathhouse was also designed for wintertime use by ice skaters.

The bathhouse at Gordon Park, as it appeared shortly after its completion in 1914, when river swimming was becoming popular.

In those days, swimmers could rent bathing suits, twenty-five cents for a woman's suit and fifteen cents for a man's. Personal swimwear had to conform to county regulations: "White bathing suits, house dresses, or one-piece suits without skirts are strictly forbidden, and full suits must be worn by all bathers more than 12."

To keep the area tidy, every year or so officials would open the gates of the North Avenue dam, lowering the river level by several feet so workers could clean trash and debris from the river bottom and perform repairs on piers and other bathing facilities.

The bathhouse witnessed many sporting events throughout the years, from canoe races and Boy Scout swim meets in the summer to hockey and speed skating in the winter. The first all-city swim meet was held at Gordon Park on July 17, 1921, with more than one hundred competitors taking part, fifty-nine in the diving events alone, watched by a crowd of onlookers both ashore and aboard canoes.[158]

Five years later, in January 1926, thirty thousand spectators turned out to watch an "ice fete" (speed skating, ski-jumping and hockey) taking place on the frozen surface of the Milwaukee River. Newspapers reported every inch of the riverbank solidly packed with spectators and thousands more

onlookers lining the Folsom Place (now Locust Street) viaduct. With the exception of college football, it was said to be the best-attended amateur sporting event in the state's history up to that time.[159]

Mostly, however, at a time when air conditioning was practically unknown, the swimming area was a fine place to cool off—and a safe one too, with four lifeguards on duty during swimming hours. One sweltering day in July 1930, 1,132 swimmers passed through the bathhouse doors.[160]

But the Gordon Park swimming area was controversial even before construction started on the bathhouse.

Opponents of the project noted the park was downstream from sewers that emptied into the river. The city's Public Works Department countered by saying the location was safe because the sewers only released surface water into the river—except when unusually heavy rain would trigger an overflow from the sanitary sewer system.

In time, the critics were proven right and the city's experts proven wrong. As the years went by, the swimming area would repeatedly close, from anywhere from a few days to a few weeks until the bacteria count dropped to a safe level. In 1931, a thick coating of decomposing sewage on the riverbed shot geysers of gas from the surface of the water and caused concern the swimming area might close for the entire summer. Suspicion fell on cottages built on the river north of the city limits, which flushed waste directly into the river.

On another occasion, a sanitary sewer in Shorewood became blocked and sewage backed into the storm system and poured, untreated, into the river for a considerable time before the problem was noticed.

Increasing pollution forced the permanent closure of the Gordon Park swimming area after the 1937 season. (The bathhouse continued to serve as a warming shelter for a few years after the swimming area was declared unsafe.) However, officials were mindful of the swimming area's popularity, which hosted as many as 100,000 swimmers in a typical summer. To give the neighborhood residents a place to cool off, the Depression-era Works Progress Administration provided $65,000 and Milwaukee Country kicked in a further $30,000 to build a modern in-ground swimming pool at the park. (That pool lasted into the mid-1990s, when it was replaced by a small splash pad.)

In 1939, the country park commission unveiled plans to remodel the river bathhouse into a year-round recreational center by improving the heating plant, removing interior stairs and using the enlarged space for dancing. The country also purchased a supply of games and cards.

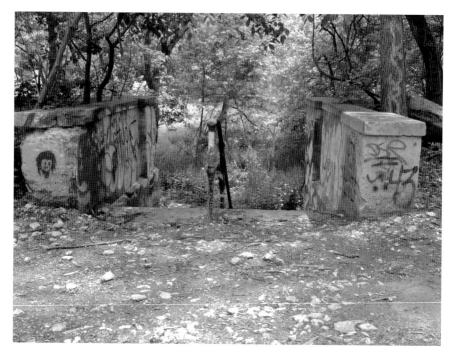

In the late 1930s, increasing water pollution forced the permanent closure of the swimming area.

Those were the days, right?

Not quite.

The building's isolation, at the foot of a steep bluff and well separated from the main park, made it an easy target. In the summer of 1948 there were numerous instances of vandalism. The building was broken into, windows shattered, fire extinguishers emptied, metal locker doors torn off, the building's loudspeaker system damaged, a safe turned upside down and light bulbs and reflectors smashed.[161]

Faced with continued repairs to a building that no longer had a purpose, the county bowed to the inevitable. The building closed and was torn down in the late 1950s. Demolition crews left the massive retaining wall in place, probably because the river still lapped against it and erosion certainly would have followed its removal.

Today, the wall, built one hundred years ago, sits high and dry and a fair distance from the river, a silent reminder of children splashing in the sun on hot days, vandals prowling on dark nights and the terrible fragility of the river's health.

NOTES

Introduction

1. Jerome A. Watrous, *Memoirs of Milwaukee County*, vol. 1 (Madison, WI: Western Historical Association, 1909), 235–36.
2. Robert W. Wells, *This Is Milwaukee* (Milwaukee, WI: Renaissance Books, 1970), 3.
3. James S. Buck, *A Pioneer History of Milwaukee, From the First American Settlement in 1833 to 1841*, vol. 1 (Milwaukee, WI: Swain & Tate, 1890), 124.

Chapter 1

4. Wells, *This Is Milwaukee*, 4.
5. William George Bruce, *History of Milwaukee City and County*, vol. 1 (Chicago: S.J. Clarke, 1922), 90.
6. Marion Lawson, "Solomon Juneau; Milwaukee's First Mayor," *Wisconsin Magazine of History* 41, no. 2 (1957): 123.
7. Western Historical Society, *History of Milwaukee, Wisconsin*, vol. 1 (1881): 76.
8. Isabella Fox, *Solomon Juneau: A Biography* (Milwaukee: Evening Wisconsin Printing Company, 1916), 11.

Chapter 2

9. Wells, *This Is Milwaukee*, ix.
10. "History of the Parks: Cathedral Square," Milwaukee County Parks, accessed August 19, 2017, http://county.milwaukee.gov/ImageLibrary/Groups/cntyParks/parkwriteups/Cathedral_Square.doc.
11. Austin H. Russell, *The Milwaukee Story: The Making of an American City* (Milwaukee, WI: Journal Company, 1946), 53
12. "New Light on the Old Courthouse," *Milwaukee Journal* (hereafter *Journal*), December 11, 1926.
13. Buck, *Pioneer History*, vol. 2, 251.
14. "Was Our Old Courthouse Copied from Russia?," *Journal*, December 7, 1927.
15. Russell, *Milwaukee Story*, 128.

Chapter 3

16. Buck, *Pioneer History*, vol. 1, 221–22.
17. Ibid., 222.
18. Wells, *This Is Milwaukee*, 54-55.
19. Kathleen Wolski and William Wawrzyn, "River on the Rebound," *Wisconsin Natural Resources*, April 2005.
20. Ibid.

Chapter 4

21. Bruce, *History*, vol. 1, 169.
22. "Lincoln's Visit to the State Fair and Milwaukee in 1859," *Milwaukee Free Press*, May 29, 1904.
23. Abraham Lincoln, "Address before the Wisconsin State Agricultural Society," accessed July 29, 2017, http://www.abrahamlincolnonline.org/lincoln/speeches/fair.htm.

Chapter 5

24. Charles B. Harger, *Milwaukee Illustrated* (Milwaukee, WI: W.W. Coleman, 1877), 28.

25. Patricia A. Lynch, "Fanny Burling Buttrick and Wisconsin's First Soldiers' Home," presentation to retirees of West Allis, Wisconsin, on Veterans Day 2011, accessed July 28, 2017, http://historicmilwaukeeva.org/West_Side_S.A.html#Refocusing_the_Mission.
26. Suzann Julin, "National Home for Disabled Volunteer Soldiers: Assessment of Significance and National Historic Landmark Recommendations," National Park Service, accessed July 28, 2017, www.nps.gov/nhl/learn/specialstudies/NHDVS/NHDVS.pdf.
27. Bleyer Brothers, eds., *Bleyer's Guild to Milwaukee* (Milwaukee, WI: Sentinel Printing Company, 1873), 37.

Chapter 6

28. Tom Tolan, *Riverwest: A Community History* (Milwaukee: Past Press, 2003), 1–2.
29. *Caspar's Guide to the City of Milwaukee* (Milwaukee: C.N. Caspar, 1904), 5.
30. "Beer Garden Memories," *Milwaukee Sentinel* (hereafter *Sentinel*), April 3, 1955.

Chapter 7

31. Danny Beson, "MKE in Wonderland: How an Amusement Park Created the Village of Shorewood," MKE Memories blog, accessed July 31, 2017, https://milwaukeehistoryblog.wordpress.com/2013/07/23/mke-in-wonderland-how-an-amusement-park-led-to-the-village-of-shorewood.
32. *Sentinel*, June 22, 1971.

Chapter 8

33. *Caspar's Guide*, 36.
34. Lewis W. Herzog, "The Whitefish Bay Resorts," *Chronicles of Whitefish Bay, Wisconsin*, edited by Thomas H. Fehring (Charleston, SC: The History Press, 2013), 139.
35. Ibid., 142.

Chapter 9

36. Larry Widen, and Judi Anderson, *Silver Screens: A Pictorial History of Milwaukee's Movie Theaters* (Madison: Wisconsin Historical Society Press, 2007), 136.
37. "Andrew C. Gutenberg," obituary, *Sentinel*, August 7, 1943.
38. Advertisement for First National Bank, *Sentinel*, December 9, 1958.
39. *Sentinel*, February 20, 1971.
40. Real estate listing, City of Milwaukee, Department of City Development, accessed July 29, 2017, http://city.milwaukee.gov/ImageLibrary/Groups/cityDCD/realestate/CommercialBldgsforSale/2917-23NHoltonSt_ListingSheet.pdf.

Chapter 10

41. *Sentinel*, July 21, 1965.
42. Andrew Jackson Aikens, and Lewis Amsden Proctor. *Men of Progress: Wisconsin* (Milwaukee: Evening Wisconsin Company, 1897) 167–68.
43. "Do You Dance," *Journal*, advertisement, September 8, 1911.
44. Aikens and Proctor, *Men of Progress*, 167.
45. *Journal*, March 11, 1962.

Chapter 11

46. "The 'Lawson' Aerial Transport," *Flight Magazine*, September 11, 1919, https://www.flightglobal.com/pdfarchive/view/1919/1919%20-%201218.html.
47. Alfred W. Lawson, *Lawson Aircraft Industry Builder* (Detroit, MI: Humanities Publishing Company, 1935), 199.
48. Ibid., Lawson quoting pilot Bud Mars, 84.
49. "Alfred W. Lawson," Wisconsin Aviation Hall of Fame, accessed August 10, 2017, http://www.wisconsinaviationhalloffame.org/inductees/lawson.htm.
50. "Lawson Plane About Perfect Says Mechanic," *Green Bay Press-Gazette*, October 26, 1917.
51. Lawson, *Lawson Aircraft Industry Builder*, 157.
52. Ibid., 199.
53. Ibid., 200.

54. Ibid., 205.
55. "First Passenger Air Liner Arrives," *Washington Post*, September 20, 1919.
56. Lyell D. Henry Jr., *Zig-Zag-and-Swirl* (Iowa City: University of Iowa Press, 1991).
57. "Plane Pioneer Dies in Texas," *Journal*, December 14, 1954.

Chapter 12

58. "Wisconsin Lakes Ice Company," *Sentinel*, February 11, 1965.
59. Lee E. Lawrence, "The Wisconsin Ice Trade," *Wisconsin Magazine of History* 48, no. 4 (1965): 257–267.
60. "Bare Bottom of the River," *Journal*, October 30, 1901.

Chapter 13

61. Ralph E. Lambrecht, "A Wisconsin Legend: Ole Evinrude and His Outboard Motor," *Wisconsin Magazine of History* 89, no. 3 (2006): 16–27.
62. "Ole Evinrude Got Hunch for Motor on Long Pull," *Journal*, December 30, 1928.
63. "An Industry Born Here," *Milwaukee Journal-Sentinel* (hereafter *Journal-Sentinel*), September 5, 2009.
64. "Mrs. Evinrude Dead; Inspired Motor Idea," *Journal*, May 13, 1933.
65. "Big Outboard Firms Combine," *Journal*, March 7, 1929.
66. "River Land Gift Is a Wilderness Peninsula," *Sentinel*, September 16, 1966.

Chapter 14

67. "Outboards Pouring Off of Metal Products Line," *Sentinel*, April 27, 1947.
68. "Flambeau," Oddjob Motors, accessed August 14, 2017, http://www.oddjobmotors.com/flambeau.htm.
69. Federal Trade Commission Decisions, "In the Matter of Outboard Marine & Manufacturing Company," Washington, D.C.: Docket 5882, Complaint May 23, 1951, Decision June 27, 1956, 1553–78.

Chapter 15

70. "Court Upholds Ziegler: He Had a Right to Protect His Property," *Journal*, April 27, 1892.
71. Bruce, *History*, vol. 2, 52–55.
72. "Candy by the Ton Manufactured in Milwaukee," *Journal*, February 8, 1920.

Chapter 16

73. Jeff Rodengen, *The Legend of Briggs & Stratton* (Fort Lauderdale, FL: Write Stuff Syndicate, 1995).
74. Wells, *This Is Milwaukee*, 187.

Chapter 17

75. "The Uihleins of Milwaukee," *Journal*, April 30, 1972.
76. Ibid.
77. Ibid.

Chapter 18

78. "Arms Plant Enables Deaf to Help in War Effort," *Journal*, May 30, 1943.
79. Ibid.

Chapter 19

80. "No Headache in 'Cure' Sales," *Journal*, July 28, 1955.
81. "Hangover 'Cure' Seized by Doubting Government," *Journal*, October 25, 1956.
82. "Amber Labs Acquired," *Journal*, June 1, 1983.
83. U.S. Environmental Protection Agency, Region V, Pollution/Situation Report Buffum MKE–Removal POLREP, August 15, 2014.

Chapter 20

84. Ernest L. Meyer, *Bucket Boy: A Milwaukee Legend* (New York: Hastings House, 1947) 45.
85. "Rise of Uihlein Dynasty: Canny August Spread Schlitz Fame to Corners of Earth," *Sentinel*, January 17, 1932.
86. "What Went Wrong?," *Journal Sunday Forum*, June 7, 1981.
87. "What Went Wrong?," *Journal*, June 9, 1981.
88. "Schlitz Brewery Won't Reopen," *Journal*, July 31, 1981.

Chapter 21

89. Aaron Zeleske, "Arboretum Spotlight: Remediation within the Arboretum," Urban Ecology Center, accessed August 1, 2017, http://urbanecologycenter.org/blog/arboretum-spotlight-remediation-within-the-arboretum.html.
90. "Increase Capital Thirty-Four Fold," *Journal*, May 13, 1902.
91. "Big Industry Built on Air," *Journal*, October 12, 1929.
92. "National Brake & Electric Plant Here to Be Wrecked," *Journal*, April 28, 1937.

Chapter 22

93. "Broke All Traditions with 'Whaleback'," *Journal*, July 30, 1933.
94. "Doomed Dock Rich in Story," *Journal*, January 5, 1930.
95. "Big Ships Collide," *Journal*, July 19, 1897.
96. Edward J. Dowling, "Red Stacks in the Sunset," *Journal of the Illinois State Historical Society* 40, no. 2 (Champaign: University of Illinois Press, June 1947): 194.

Chapter 23

97. "Fell from Third Deck," *Journal*, July 2, 1917.
98. "Owners Say Current Caused Accident," *Sentinel*, July 2, 1917.
99. Ibid.
100. Ibid.

Chapter 24

101. "Marrying in Haste: How Mr. Hunsberger Unites a Dozen Couples in One Hour," *Journal*, quoting an article originally from the *Chicago Tribune*, November 3, 1895.
102. Ibid.
103. "Hulsey to Hunsberger: The Former Pastor of Grand Avenue M.E. Church Quoted by His Successor," *Journal*, November 16, 1895.
104. "Few Runway Marriages in Future," *Journal*, April 27, 1899.

Chapter 25

105. Bruce, *History*, vol. 1, 54.
106. Ibid., 53.
107. "Thriving Community Evolved from Hamlet," *Journal*, November 6, 1911.
108. "Green Bay Avenue on the Rebound," *Sentinel*, July 23, 1984.

Chapter 26

109. "Catholic Orphanages in the Archdiocese of Milwaukee," Archdiocese of Milwaukee Archives, accessed August 3, 2017, https://www.archmil.org/offices/archives/Orphanage-Records.htm.
110. "Funerals Held for 2 Orphans," *Journal*, February 25, 1929.
111. "183 Boys Escape Blazing Orphanage," *Journal*, May 22, 1930.

Chapter 27

112. "Remember! Hat Pin Ordinance Is Now in Effect in Milwaukee," *Journal*, April 2, 1913.
113. "Masher Gets Limit: Hatpin Chase Is Followed by a Six-Month Sentence," *Journal*, February 13, 1909.

Chapter 28

114. Board of Park Commissioners, "Nineteenth Annual Report of the Park Commissioners of the City of Milwaukee, 1909," (Milwaukee, Phoenix Printing Company, 1910), 10.
115. Ibid., "Twenty-First Annual Report of the Park Commissioners of the City of Milwaukee, 1911," Milwaukee, Edward Bulfin, printer, 1913, 12.

Chapter 29

116. Laurie Muench Albano, *Milwaukee County Parks* (Charleston, SC: Arcadia Publishing, 2009), 26.
117. "Beautiful Lake Park by Moonlight," *Journal*, June 19, 1897.
118. "Are Streetcars Following Horsecars into Oblivion?," *Journal*, December 26, 1937.

Chapter 30

119. Joseph M., Canfield, ed., *The Milwaukee Electric Railway & Light Company* (Chicago: Central Electric Railfan's Association, 1972), 417.
120. "Fire Sweeps Lumber Yard, Closes Trestle," *Journal*, June 8 1946.

Chapter 31

121. *Sentinel*, February 4, 1895.
122. Robert W. Wells, *Yesterday's Milwaukee* (Miami, FL: E.A. Seeman Publishing, 1976), 63
123. "Steamer Wrecks Swinging Bridge; Interurban Car Hangs in Midair," *Journal*, July 19, 1905.
124. "Ran His Streetcar into Auto Is Charge, Motorman Says No," *Journal*, December 13, 1947.

Chapter 32

125. "City Has Been Beautified for You, Elmer," *Journal*, September 14, 1941.
126. "End of Line in Sight for Towering Depot," *Journal*, February 2, 1968.
127. Jim Scribbins, *The Hiawatha Story* (Milwaukee, WI: Kalmbach Publishing Company, 1970), 23.

Chapter 33

128. Ibid., 70.
129. Jim Scribbins, *The 400 Story* (Milwaukee, WI: Kalmbach Publishing Company, 1982), 26.

Chapter 34

130. Interview with the author.
131. Art Harnack, *The Milwaukee Road's Beer Line* (Antioch, IL: Milwaukee Road Historical Society, 2003), 7.

Chapter 35

132. Old Settlers Club, *Early Milwaukee: Papers from the Archives of the Old Settler's Club of Milwaukee, 1830-1890* (Milwaukee, WI: Old Settlers Club), 105–9.

Chapter 36

133. "Remember the Daphne Boat Club?," *Journal*, September 6, 1935.
134. "Crowd of 5,000 Defies Sun at Aquatic Show," *Journal*, August 15, 1938.
135. "Throng of 50,000 at Water Fete on Milwaukee River," *Sentinel*, August 6, 1913.
136. Ibid.
137. "Hope Increases for a Revival of Happier Days Along River," *Journal*, 1964.

Chapter 37

138. Howard Greene, and William T. Berthelet, "The Milwaukee Cement Company," *Wisconsin Magazine of History* 33, no. 1 (September 1949): 28–39.
139. Robert E. Gard, *The Romance of Wisconsin Place Names* (Madison: Wisconsin Historical Society Press), 300.
140. "Preserve Cement Lake," *Journal*, June 24, 1929.

Chapter 38

141. "Only Guarded Beaches Safe: Sheriff Warns Bathers of Unprotected Spots and Quarries," *Journal*, July 8, 1921.

Chapter 39

142. "Killjoy to Nab River Spooners," *Journal*, August 2, 1921.
143. "Sees 'Breakers' Before 'Killjoy'," *Journal*, August 5, 1921.
144. "Killjoy a Life Saver, Our Police Navy Says," *Journal*, July 12, 1931.
145. "Jacob Laubenheimer 1921–1936," City of Milwaukee, accessed August 21, 2017, http://city.milwaukee.gov/Directory/police/About-MPD/Chief/Jacob-Laubenheimer-1921-1936.htm.
146. "Killjoy Ill; Will Take Rest Cure," *Journal*, September 13, 1921.
147. "Police Dampen Spooning Party," *Journal*, May 15, 1922.
148. "Killjoy a Life Saver, Our Police Navy Says," *Journal*, July 12, 1931.
149. "Killjoy Tuned Up, Interrupts Three Friendly Couples," *Journal*, June 15, 1925.

Chapter 40

150. "Mallard Sets an Eggs-Ample in a 'Penthouse' 10 Feet Up," *Journal*, April 28, 1945. A photograph and caption of the bridge tender with the duck nest was accompanied by a story on page three.
151. "'Gertie' Co-Author Remembers Famous Foul," *Journal-Sentinel*, December 1, 1997.
152. Wells, *This Is Milwaukee*, 229–33.

153. "They're Here! 3 Junior Gerties Unshelled; One Seems Likely to Come to No Good End," *Journal*, May 30, 1945.
154. "Gertie Brood Rescued; Egg Is Hatched for Her," *Journal*, May 31, 1945.
155. *Journal-Sentinel*, March 1, 2001.

Chapter 41

156. "River Colony Fears Shut-In," *Journal*, December 17, 1935.

Chapter 42

157. Board of Park Commissioners, "Twenty-First Annual Report of the Park Commissioners of the City of Milwaukee, 1911," Milwaukee: Edward Bulfin, printer, 1913, 9.
158. "Swimmers to Compete at Gordon Park," *Journal*, July 17, 1921.
159. "A Little Snow—A Little Ice—But a Big Municipal Winter Sports Carnival," January 10, 1926.
160. "85,000 Visit Parks, Beaches Draw Many," *Journal*, July 27, 1930.
161. "County Is Hit by Vandalism," *Journal*, October 29, 1948.

INDEX

A

airliner, first practical 56
airport, first municipal 57
Albrecht, Jim 156
Amabilis, Sister Superior Mary 126
Amber Laboratories 91

B

beer garden 34, 43
Beer Line 91, 157
Beerline Trail 158
Belle Isle Canoe Club 176
Benn, Paul 180
Bernstein, Sheldon 93
Berthelet, Joseph 166
Betty Brinn Children's Museum 151
Bigelow, Frank G. 101
Blatz Park 34, 40, 67, 163
Bloomer Girl, steamship 44
Blue Hole 167
Blue Hole raid 171
Bogk, William 122
Bohan, Alice 130
Boll, John and Andrew 79
Brewery Workers Local 9 99
Briggs Loading Co. 82
Briggs, Stephen 82
Briggs & Stratton
 Briggs Loading Co. 82
Brodie, Jim 116
Bryan, William Jennings 52
Buck, James S. 18, 22
Bullhead Bay 162
Burnelli, Vincent 58

C

Cambridge Woods neighborhood 182
Cambridge Woods Park 182

Index

Candy Raisins 81
Capitol Drive bridge 160
Cathedral Square 18
Cement Lake 167
Chicago, Milwaukee, St. Paul & Pacific Railroad 148
Chicago & North Western Railway 148, 152, 182
Chill-garde, brewing ingredient 97
Christensen Engineering Co. 101
Christensen, Niels 100
Christopher Columbus
 accident 114
 steamship 108, 118
Civil War, caring for wounded of 29
Clement J. Zablocki Veterans Administration Medical Center 29
Columbian Exposition 109
Coney Island amusement park 40
courthouse
 first 18
 second 19
Cox, Charles 59
Cream City Cement Co. 168
Currie Park 57, 63
Cutler-Hammer 82

D

Daphne Boat Club 162
deaf workers, employment of 89
De Graace, George 180
Depression 71, 78, 103, 113, 152, 169, 170
Direct Credits Society. *See* Lawson, Alfred W.

Djeska, Joseph 126
Dore, Scotty 163
downtown 14, 30, 83, 114, 118, 150
Dreamland Ballroom 50

E

East Side 14
East Side neigborhood 18
Edward P. Allis Co. 69, 100
Ehlman, Antoinette 143
electrical tower 41
Eline's Chocolate & Cocoa Company 85
Engelhorn, Edward 74
Estabrook Park 83, 166, 168, 170
 swimming beach 170
Evinrude 69
Evinrude, Bessie Cary 69
Evinrude, Ole 69

F

Federal Trade Commission
 Outboard Marine trade practices 76
Finch, Elliot 124
Flambeau outboard motors 74
Folsom Place depot 182
400, passenger train 152

G

George Ziegler Candy Co. 78
Georgiady, Nicholas 179

Gertie the Duck 178
Giganti, Philip 126
Gimbel's Department Store 181
Glendale
 Briggs Loading Co. 82
 Eline Chocolate Co. 85
Glover, Joshua 19
Goddess of Liberty, statue of 20
Goll, Henry G. 101
Goodrich Transportation Co. 110, 114
Gordon Park 156
 bathhouse 176, 185
Grand Avenue Methodist Episcopal Church 118
Grand Theater 47
Greb, Albert 144
Green Bay Avenue Business Association 124
Green Bay Avenue, business district of 121
Grootemaat, John, Sr. 122
Gutenberg, Andrew and Evelyn 47

H

Halsey, Rev. Dr. Sabin 120
hatpin ordinance 129
Hautz, Larry 180
Hiawatha passenger train 150, 152
Hilty-Foster Lumber Co., fire 141
Hippodrome 52, 53
Hoelzer, Fred 130
hometown 68
Hoyt, John Wesley 25
Hubbard Park 38, 163, 183
Humboldt, former town of 160
Hunsberger, Rev. Wesley A. 118

I

Ice Fete 186
ice harvesting, business of 64
icehouse 66
Ice War, the 64
Indian trail 121
industries
 Amber Laboratories 91
 Milwaukee Cement Co. 167
International Harvester 82
Isenring, Fred G. 43
Izaak Walton League 180

J

Jager Lumber & Manufacturing 91
Johnson outboard motors 76
Jos. Schlitz Brewing Company 94
 Eline's Chocolate Co. 85
Julius Goll, steamship 67
Juneau, Josette 14, 16
Juneau Park 14
Juneau, Solomon 14

K

Karnatz, Irvin 176
Kearsarge, steamship 143
Kennedy, John W. 143
Kern Park 132, 163
Ketchel, Stanley 53
Kilbourn, Byron 16, 21, 159
Kilbourn Town 16
Killjoy, police river patrol 174
Kincannon, Leo 74

Index

Kinnickinnic River
 Evinrude, first engine tested 70
Koether, Henry 172
Konopka, Henry 43
Kopmeier, John 66
Kroha, Rev. Joseph F. 127
Krug, August 94
Kuehn, George L. 74

L

La Crosse & Milwaukee Railroad 156, 159
Lake Freeway, plans for 183
Lake Front Depot 148, 151
Lake Park 136
 trolley station 137, 138
Laubenheimer, Jacob 174
Lawson Airline Company 56, 61
Lawson, Alfred W. 56
Lawson C-2, aircraft 56
Lawson MT-1, aircraft 58
Lawsonomy. *See* Lawson, Alfred W.
Lincoln, Abraham 25, 30
Locust Street bridge 175, 182
Lueddemann, Frederick 38
Lueddemann's-on-the-River 38, 164
Lundwall, Harold 169

M

MacQuarrie, Gordon 178
Martin Luther King Drive 121
Martin, Morgan 16, 18
McDougall, Capt. Alexander 108
Menomonee River 15

Christopher Columbus accident 114
Metal Products Corporation 74
Mickelsen, Gunner 44
Midnight Airliner 61
 crash of 62
Milbew 91
Millen, Matt 49
Milwaukee Cement Co. 83, 167, 170
Milwaukee-Downer College 177
Milwaukee Electric Railway & Light Co. 136, 140
Milwaukee industries
 Briggs Loading Co. 82
 Eline's Chocolate & Cocoa Co. 85
 George Ziegler Candy Co. 78
 Jos. Schlitz Brewing Company 94
 National Brake & Electric Co. 100
 Wisconsin Lakes Ice Company 66
Milwaukee marriage 118
Milwaukee Ordnance Plant 88
Milwaukee Police 171, 174
Killjoy 174
Milwaukee Police Department
 Marine Operations Unit 177
Milwaukee River
 amusement park, Shorewood 40
 Blatz Park 34
 boat livery 35
 Daphne Boat Club 162
 Evinrude Test Facility 69
 icehouses 66
 last natural ice harvest 68
 Riverside Park 100
 steamboats on 35
Milwaukee Road 148
 Beer Line 91

Milwaukee & Rock River Canal Co. 21
Milwaukee Rowing Club 164
Milwaukee Street Railway Co. 78, 136, 139
 Lake Park Depot 137
Milwaukee & Waukesha Railroad 156
Milwaukee & Wauwatosa Motor Railway Co. 139
Milwaukee & Whitefish Bay Railway 44
Mineral Spring Park 39
Mirandeau, Jean Baptist 15
Miswald, Grant 144
Mitchell Park 15
Mix, Edward Townsend 150
Moody, Capt. Charles 115, 117

N

National Brake & Electric Co. 100
Neubert, Henry P. 130
Newhall House 27
Newport Chemical 82
North Avenue bridge 35, 67, 162
North Avenue dam 21, 64, 67, 69, 162, 170
North Bush Lane 72
Northwestern Branch of National Home for Disabled Volunteer Soldiers 29
Northwestern Union Railway 39
Novakovich, Frank 126
Novakovich, Paul 126

O

Oak Creek
 Newport Chemical 82
Oak Leaf Trail 152, 182
O'Connor, "Captain" Phillip H. 35
Old Settlers' Club 159
Outboard Motors Corp. 71

P

Pabst, Capt. Frederick 43, 110
Pabst Whitefish Bay Resort 43
Papke, Billy 53
parks
 Cambridge Woods Park 182
 Cathedral Square 18
 Currie Park 57, 63
 Estabrook Park 83, 166, 168, 170
 Gordon Park 185
 Hubbard Park 38, 163
 Juneau Park 14
 Kern Park 132, 163
 Lake Park 136
 Mineral Spring Park 40
 Mitchell Park 15
 Pleasant Valley Park 34
 Ravenna Park 41
 River Park 41
 Riverside Park 100, 136, 164, 183
Pike & North Lakes Ice Co. 66
Pinkley, Roy 138
Pipkorn, Frank 104
Pleasant Valley Canoe Club 164
Pritkin, Henry 129
Prohibition 36, 86
Public Service Commission 183

Q

Quaff-Aid 91
Quin, Jeremiah 159

R

Ravenna Amusement Park 41
Rehorst, Alex 180
Rice, Donald W. 99
Riemer, Erwin 175
Riot of 1967 123
River Colony 182
Riverwest neighborhood 66, 132, 156, 159
Robinson, Lansing 162
Romano, Lou 179
Rotary Centennial Arboretum 100

S

Schlitz 94
 Palm Garden 109
Schlitz, Joseph 94
Schmidkunz, Katie 143
Schultz, Fred 180
Scribbins, Jim 152
Shorewood 38
Smith, Uriel B. 16
Social Workers' Tuberculosis Sanitarium 133
Soldiers' Home 29
South Milwaukee 61
South Milwaukee line interurban 143

St. Aemilian Orphan Asylum 125
 fire 127
 poisonings 125
Steinhagen, Gustave 139
St. Francis Seminary 125
Stratton, Harold 82

T

Taft, William Howard 83
Taylor, Emma 114, 116
tuberculosis 132

U

Uihlein, Alfred 95
Uihlein family 85, 95
Uihlein, Joseph E., Sr. 86
Uihlein, Robert 97
Union Station 150
United States Rubber Co, operator of Milwaukee Ordnance Plant 88
Urban Ecology Center 100
U.S. Environmental Protection Agency
 Superfund cleanup 93

V

Venetian night water carnival 163
Vieau, Jacques 14
Virginia, steamship 110

W

Walker, George H. 16
Walker's Point 16
Washington Park 136
Watkins, Samuel W. 101
Wauwatosa 57
Wells Street viaduct 139
Westinghouse Manufacturing Co. 102
whaleback, ship design 108
Whitefish Bay, village of 43
Whitt, Dorothy 154
Wilcox, Clarence H. 62
Williamsburg, village of 122
windmill 122
Wirth, Andrew Charles 50
Wirth, Jennie 52
Wisconsin Electric Power Co. 140
Wisconsin Lakes Ice Company 66
Wisconsin State Fair 25
Wolff, Col. Arthur M. 89
Wonderland amusement park 35, 40
Woods, Frank 117
Works Progress Administration 187
World War I 58, 82, 162
 National Brake & Electric Co. 102
World War II
 Gertie the duck 178
 Milwaukee Ordinance Plant 88

Z

Ziegler, Bill and Mary 81
Ziegler, Frank 78
Ziegler, George 79

Ziegler Giant Bar 81
Zwietusch, Otto 39

ABOUT THE AUTHOR

Carl A. Swanson explores and writes about his adopted hometown of Milwaukee. A magazine editor and author of *Faces of Railroading* from Kalmbach Publishing Company, Carl studied journalism at the University of Nebraska–Lincoln, and photography at the Woodland School of Photography. He lives in Milwaukee with his wife and three children and blogs about the city and its history at MilwaukeeNotebook.com.